# ARTS AND THE MAN

*Norton Library titles in*

*Art, Architecture and the Philosophy of Art*

# ARTS
# AND THE
# MAN

*A Short Introduction to Aesthetics*

## IRWIN EDMAN

The Norton Library

W · W · NORTON & CO · INC ·

NEW YORK

ARTS AND THE MAN *is a revised and enlarged edition of the author's book published in 1928 under the title* THE WORLD, THE ARTS AND THE ARTIST.

Books That Live

The Norton imprint on a book means that in the publisher's estimation it is a book not for a single season but for the years.

W. W. Norton & Company, Inc.

PRINTED IN THE UNITED STATES OF AMERICA

6789

# CONTENTS

5

# PREFACE

THIS book is intended, as it was originally, as a short introduction to aesthetics. It is not meant to initiate the reader into the categories of the subject as it is discussed in the dialectic of controversy. It is simply a consideration of the arts out of which aesthetic reflection arises, and the experience out of which the arts grow, which they clarify and which they enhance.

The occasion of a new edition, a new format, and a new and, I trust, more convenient title, offers an opportunity to expand one chapter which in the original edition was but a clue to what I have long wished to discuss more extensively: the relations of Art and Philosophy. For those relations seem to me to throw a fresh light at once on the significance of major art and on the imaginative meaning of major philosophies. In what sense art is important to a philosopher, in what respect philosophy is

a form of art, the point at which art and philosophy meet, the paths into which they diverge—these themes seem to me of more importance than can decently be compressed into three pages even of a modestly proportioned essay.

For the rest, the book remains what it was: a short introduction to the experience of the arts and the implications of art in civilization. The first chapter attempts to indicate the general relations of art to the whole of our experience; the second, the origins and the functions of the artistic process in civilization. The remaining chapters try to state the special ways in which, through their special media, the arts clarify, vivify, and unify our experience. To say more would have been to say much more; to raise subtler issues would have been to explore each of the arts beyond the competence of the general reader or of the author, and to develop themes involving all the major issues of morals, logic, and metaphysics. This is a primer of the aesthetic experience. As such it has seemed to find many friendly users. I hope someday to write a more extensive work to which I shall invite the reader. For the present I leave the book, save for one expanded chapter, essentially unchanged, and refer the reader to the arts themselves for further enlight-

## PREFACE

enment, or, I trust, for confirmation of the hypotheses
suggested here. A book on aesthetics is justified not so
much by leading the reader to further books on aesthetics,
but rather by returning him to the arts, a return, it
is to be hoped, marked by sharpened and deepened
appreciation.

# ONE

## ART AND EXPERIENCE

WHATEVER life may be, it is an experience; whatever experience may be, it is a flow through time, a duration, a many-colored episode in eternity. Experience may be simple as it is among babies and simple people; it may be complex as it is in the case of a scientist or poet or man of affairs. It may range from the aimless movement of a baby's hands and the undisciplined distraction of its eyes to the controlled vision and deliberate movements of the champion marksman. It may move from the beholding and manipulation of physical things to the invention and organization of ideas tenuous and abstract. But between birth and death, this much may be averred of life, it is the stimulation and response of a living body, of "five little senses startling with de-

light," of muscle twitching to answer with action, of hands eager and restless, of a tongue moved to utterance and a mind provoked to thought. Portions or aspects of that experience may be remembered and recorded. Totally considered, it may be aimless or purposeful. It may be merely the veil or revelation of something behind or beyond experience itself. It may be merely a systematic transient delusion. It may be a nightmare or a dream. Philosophers and poets have espoused at one time or another all these hypotheses.

But whatever experience may portend or signify, veil or reveal, it is irretrievably there. It may be intensified and heightened or dulled and obscured. It may remain brutal and dim and chaotic; it may become meaningful and clear and alive. For a moment in one aspect, for a lifetime in many, experience may achieve lucidity and vividness, intensity and depth. To effect such an intensification and clarification of experience is the province of art. So far from having to do merely with statues, pictures, and symphonies, art is the name for that whole process of intelligence by which life, understanding its own conditions, turns them to the most interesting or exquisite account. An art, properly important, would be, as Aristotle pointed out, politics. Its

theme would be the whole of experience; its materials and its theater the whole of life.

Such a comprehensive art is still the statesman's dream. The conditions of life, especially of life together, are as complex as they are precarious. We do not know enough about them to be sure of our touch, nor has any man enough power to be sure his touch is translated into action. An artist bent on turning the whole of life into an art would have to be at once a universal despot and a universal genius, a Goethe, a Newton, and an Alexander rolled into one. The art of life is an aspiration and a prophecy, not a history or a fact.

The artist de facto has had to deal with segments of experience, though he may suggest or imply it all. Experience, apart from art and intelligence, is capricious and confused. It is matter without form, movement without direction. The passing sounds are a vague noise unattended or undesired; the colors and shapes about us are unnoticed or unpleasant. The words we hear are signals to action; if they are that. Now to a certain extent life has achieved form. As we shall try to point out in the succeeding chapter, civilization itself is an art form, highly successful and fortuitous, but none the less an art.

To the extent that life has form, it is an art, and to the

extent that the established disorder of civilization has some coherence, it is a work of art. All that goes by the name of custom or technique or institution is the working of intelligence or its perhaps dilapidated heritage. The realm of art is identical with the realm of man's deliberate control of that world of materials and movements among which he must make his home, of that inner world of random impulses and automatic processes which constitute his inner being. The breaking of a stick, the building of a hut, a skyscraper, or a cathedral, the use of language for communication, the sowing or the harvesting of a crop, the nurture and education of children, the framing of a code of law or morals, the weaving of a garment, or the digging of a mine—all these are alike examples of art no less than the molding of a relief or the composition of a symphony.

It is for purely accidental reasons that the fine arts have been singled out to be almost identical with Art. For in painting and sculpture, music and poetry, there is so nice and so explicit a utilization of materials, intelligence has so clear and complete a sway over materials at once so flexible and delightful, that we turn to examples of these arts for Art and in them find our aesthetic experience most intense and pure. But wherever materials

are given form, wherever movement has direction, wherever life has, as it were, line and composition, there we have intelligence and there we have that transformation of a given chaos into a desired and desirable order that we call Art. Experience, apart from art and intelligence, is wild and orderless. It is formless matter, aimless movement.

It is difficult to realize how much of our diurnal experience is what William James called it, "a big blooming buzzing confusion." It is hard to realize how much of it is a semistupor. Life has often enough been described as a waking dream. But not much of it has the vividness, though a great deal of it may have the incoherence or the horror of a dream. For most people most of the time it is a heavy lethargy. They have eyes, yet they do not, in any keen and clear sense, see. They have ears, yet they do not finely and variously hear. They have a thousand provocations to feeling and to thought, but out of their torpor comes no response. Only the pressure of some animal excitement, instant and voluminous, rouses them for a moment to an impulsive clouded answer. Life is for most of us what someone described music to be for the uninitiate, "a drowsy reverie, interrupted by nervous thrills."

How is this dazed basking in the sun, or this hurried

passage from an unwilled stimulus to an uncontrolled response, transformed? How does an artist remake experience into something at once peaceful and intense, domestic and strange? What does the artist do to the world to render it arresting? What part do the arts play in our experience that gives them a special seduction and delight?

Ordinary experience, that of practical or instinctive compulsion, is at once restless and dead. Our equipment of habits and impulses is such that we see and hear just so much of objects, partake imaginatively just so much in events as is necessary for the immediate satisfaction of impulses or the fulfillment of practical intentions. Our instincts and our necessities hasten us from object to object. From each we select just as much as is requisite to our desires or to our purposes, the bare minimum of all that to free and complete aesthetic apprehension would be there. Just as meat to the dog is something to be eaten, and the cat simply something to be chased, so the chair to a tired man or an executive is simply something to be sat on; and to the thirsty man water, however lovely its flow or sparkle, simply something to be drunk. The man of affairs intent upon future issues or the next step, the scientist interested in some special consequence

of the combination of two elements, the hungry or the lustful intent upon the fulfillment of one absorbing and immediate desire—all these hasten from moment to moment, from object to object, from event to event. Experience is a minimum and that minimum is bare. Only one aspect of its momentary practical or impulsive urgency is remembered; all else is forgotten or more precisely ignored.

It is one of the chief functions of the artist to render experience arresting by rendering it alive. The artist, be he poet, painter, sculptor, or architect, does something to objects, the poet and novelist do something to events, that compel the eye to stop and find pleasure in the beholding, the ear to hear for the sheer sake of listening, the mind to attend for the keen, impractical pleasure of discovery or suspense or surprise. The chair ceases to be a signal to a sitter; it becomes a part and a point in a composition, a focus of color and form. It becomes in a painting pictorially significant; it becomes alive. That passing face is not something to be persuaded or conquered or forgotten. It is to be looked at; it is an object of pictorial interest, at once satisfying and exciting. It ceases to be an incident or an instrument; it is not a precipitate to action, a signal to anger or to lust. It is a moment crowded

with vitality and filled with order; it is knowledge for its own sweet sake of something living and composed; it is beautiful, as we say, to look at, and its beholding is a pleasure.

Painters sometimes speak of dead spots in a painting: areas where the color is wan or uninteresting, or the forms irrelevant and cold. Experience is full of dead spots. Art gives it life. A comprehensive art, as has been intimated, would render the whole of life alive. The daily detail of doing or undergoing would be delightful, both in its immediate quality, and for the meaning that it held. Our relations with others would all have something of the quality of friendship and affection; what we did would be stimulating as it is stimulating to a writer to write or to a painter to paint. What we encountered would be like an encounter with music or with painting or poetry. To live would be a constant continuum of creative action and aesthetic appreciation. All that we did would be an art, and all that we experienced would be an appreciation and a delight. Living would be at once ordered and spontaneous, disciplined and free.

There are a dozen reasons why that perfect functioning which would be an art of life is the philosopher's blueprint and the poet's dream rather than a fact. In the

life of the individual, a thousand factors of health and fatigue, of external circumstance, of poverty and responsibility, combine to defeat the deployment of resilient energies with exquisite wisdom. Pure spirit must rely on poor matter; the clearest intelligence on a body and world which are at once its matrix and its materials. The dead spots in experience are not avoidable. As life is constituted in a disorganized world, much that has to be done is incidental and instrumental. We work for leisure and we rush for peace. The work is not sweet nor the pursuit calm. A lowering of vitality clips the wings of youth and exuberance. The presence of dull people turns conversation into ennui. The ugliness of our streets, our houses, and our cities is a realistic interruption of what might, ideally speaking, be perpetual delight.

That is one reason among a thousand others why the artist and the aesthete flee to the fine arts. It is one reason, too, why art is regarded so often and has so repeatedly been described as a flight from life. The fine arts are in two senses a flight from reality. For the artist they provide a realm where his intelligence can function freely over tractable materials. The technical problems of the poet or musician may be difficult, but they are solvable, and their solving is itself a tantalizing kind of felicity.

The musician, like the mathematician, lives in a complex but tractable realm. It is vast, airy, and metaphysical, but in it his intelligence can freely function, and his faculties can find their peace.

It is often remarked that artists are helpless in practical life. Its problems are to them dull or baffling or both; in its helter-skelter miscellany, their intelligence, disciplined to one sphere, as fine as it is small, cannot feel at home. It is not to be wondered at that the world finds the artist often foolish in affairs, any more than that the artist should find the affairs of the world foolish. What is a mind fastidious and precious to do with the awkward grossness of things and events? What is a spirit to whom a discord is an evil to make of the jangle of politics and morals? So many poets have been romanticists and visionaries because their sensibilities, quick and nervous, could not bear to live in the world of facts. Poets of the first water, it is true, have been prepared to look steadily upon all that existed under the sun, and celebrate things, as André Gide well said, by enumeration. Painters as different as Rembrandt and Degas have learned to look at things in their immediacy ugly and distressing, a tired worker, an aged woman, and, through some magic of line and light, turn them into a beautiful peace. But for

artists, gifted in their power but restricted in their range and courage, the arts have been escapes from a reality they could not bear, to a section of color and light, of sound, of imaginative reverie, which was not only bearable but beautiful.

Shelley turns from the cruelty and stupidity of nineteenth-century England to a Utopia, Platonic in its spiritual beauty and classic in its marmoreal precision. Beethoven in his deafness and suffering listens, in the choral finale movement of the Ninth Symphony, to his own concluding paean to the world as pure fellowship and joy.

The impulses that go to the making of the romantic artist go to the formation, too, of romantic appreciation. For many lovers of the arts find in music, poetry, painting, and the novel escapes, as narcotic as they are delightful, from the pressures and exigencies in which we are involved by our health, our finances, and our affections. The shopgirl's novel has been the *locus classicus* in illustration of the theory of art as an escape. In its pages, the drab little person can move in luxury with princes, duchesses, and movie stars. She can possess vicariously beauty and freedom. The clerk tied to his desk can move in adventure novels, through the open spaces, and be, in

the person of a robust romantic figment, a hero all strength and chivalry.

But the novel is not the only art that yields escape. It does so by its vicarious leading of the imagination through paths we have longed to tread but have never trodden, through lands we have never known, including palaces that never were on land or sea. Other arts offer subtler escapes. Schopenhauer pointed them out with classic persuasion, many years ago. Aesthetic interest is itself detachment, though it is not the kind of detachment that it is commonly supposed to be. But any perusal of a painting by the eye is a kind of release from our normal habits. For that moment at least we are looking at things for, and only for, themselves, not for their promise or their portent. It is the color of the apple in a still life that engages us, it is something to be seen vividly, not to be grasped at in hunger. The aesthetic is substituted for the practical vision; in Schopenhauer's language, knowledge, for the moment, comes to predominate over will. It is notable how in the late nineteenth century a romantic pessimism and a romantic aestheticism were allied. The hungry will might never find its satisfaction or its peace in a world that was doomed never to satisfy it. Life might be an eternity between two oblivions, a vast anacoluthon,

a sentence without a meaning. Be it so. In that brief interval, one might, as Pater suggests in his famous conclusion to *The Renaissance,* be filled with light and color and music. One could escape from the defeats of the intellect and the emotions to an exquisite Epicureanism. As far as possible, as far as one can live in the aesthetic experience itself, one can make life a continuum of roses and raptures. One can escape the times that are out of joint, like Richard II, in a harmonious music. In the still perfection of marble, in the fine modeling of a face in a painting, or of the shadows on a wall, one can escape into a realm of eternity. In music, too, emotions finer and subtler than any ever experienced can be enjoyed. And in literature, even pain and distress may be experienced at arm's length and in the garb of beauty. For the observer, one function of the fine arts is certainly to provide the peace of beauty and the escape of detachment. Broadly speaking it is not the practical functions but the eternal essences of things that the arts provide. To behold an essence is to behold something in and for itself. The purely aesthetic observer has for the moment forgotten his own soul, and has gained the world, that is to say, the world of art.

This theory and ideal of aesthetic appreciation has a

particular following among those in whom sensibility is combined with disillusion. The aesthete is a melancholy exquisite loitering among the gleams in a fading world. There is no doubt that the arts must for many be nothing more than such a flight. The saint flees to his desert, the aesthete to his tower of ivory. One finds his peace in God, the other in form.

The fact is, however, that this theory of art as escape fails to take into account much that is true of aesthetic experience, and is an insult to the more rich and positive aspects of aesthetic enjoyment and production. It abstracts the Aesthetic Man much as the early nineteenth century abstracted the Economic Man. No one is ever, or ever for long, an aesthetic observer, and part of aesthetic enjoyment is the rendition, vivid and revealing, of the world we know and the nature we are. The eye of the beholder is the eye of a human being, with all the vast reverberation of human interests and emotions. The ear of a listener is the ear of one to whom sounds have associations and of one who has listened to words for their meaning as well as for their tintinnabulation. The arts may be, in many instances and for many observers, flights into a compensatory dream or into a Paradise of forms,

lucid and satisfying, in which the apprehension is satisfied and the conflicts of experience are lulled.

There is a more melodramatic sense, too, in which the arts may be escapes. Nietzsche pointed out in *The Birth of Tragedy* the elements, complementary and apparently contradictory, in Greek tragedy, and in all moving art. These he defined as the Apollonian, the element of repose, and the Dionysian, the element of passion and vitality. The arts do more than bring or bestow peace; they communicate fire. In the high climaxes of the fine arts, the psyche, condemned in the ordinary circumstances of living to be diffident and constrained, finds a provocation, an outlet, and an excuse for those fires which are ordinarily banked. Nietzsche was for a time peculiarly seduced by Wagner because he felt in the urgency and flow of that romantic musician precisely the Dionysian element which was for him the lifeblood of the arts. "Literature," says Anatole France, "is the opium and hasheesh of the modern world." Rather it might be said to be music. One has but to gaze at the faces of a modern concert audience to see how, in the swelling tide of some orchestral climax, passions are finding their release that have found no other utterance; music is saying un-

ashamed what most of its listeners would be as ashamed as they would be unable to say in words.

Nor is it only the madder moments of passionate assertion that find their expression in the arts. Nuances of feeling, subtleties of thought that practical experience keeps us too gross or too busy to observe, that words are too crude to express, and affairs too crude to exhaust, have in the arts their moment of being. For these reasons, too, for the observer, they are absorbing flights from life. But they may—in major instances they do—clarify, intensify, and interpret life.

First, as to the intensification: our senses, we learn from the biologists, are adaptations to a changing and precarious environment. They were developed, in the long animal history of the race, as instruments by which a troubled animal might adjust itself to a constantly shifting experience. A pigmented spot sensitive to light becomes eventually the eye. That organ enables the animal to estimate at a distance the dangerous and desirable object too far removed for touch. The ear, similarly the product of a long evolutionary history, likewise originated as an instrument that rendered the animal advertent to the dangers and promises in a mysterious and uncertain environment. Smell, in its animal origin, was

likewise a warning of the noxious, a signal of edible or otherwise promising things. Taste, too, developed as a rough guide to the poisonous and the nourishing. Touch began as that near and immediate sensitivity closely bound up with self-preserving and procreative lusts.

In their origin our senses are thus practical, not aesthetic. They remain in diurnal living, essentially practical still. There is, as it were, a myopia to which we are all subject. Rather we are all subject to a blindness, instinctive and compulsive. We become anaesthetic to all phases of objects save those in which our immediate fortunes or actions are concerned.

The artist's function, the success of a work of art, are both partly measurable by the extent to which our senses become not signals to action but revelations of what is sensibly and tangibly there. Somewhere Stephen Crane has a story of three men shipwrecked in a small boat on a wide and stormy sea. The first sentence is, "They did not see the color of the sky." So intent were they upon the possibilities of being saved that they had no time, interest, or impulse for seeing the color of the sky above them.

In the fine arts, then, the experience becomes intensified by the arresting of sensations. We become aware with

tingling pleasure of the colors and shapes on a canvas, of the sounds of a voice or a violin. The other senses, too, have their possible aesthetic exploitation, but touch, taste, and smell are not as finely manipulable, not as easily incorporated in objects or detached from practical biological interests as are sight and sound. The peculiar function of the fine arts lies, therefore, chiefly in the realm of these two subtle and finely discriminated organs, the eye and the ear. Color, which for practical purposes is usually the most negligible aspect of an object, is the painter's special material. Differences in rhythm and tone, negligible in practical communication, become for the musician the source of all his art, for the music lover the source of all his pleasure. The senses from being incitements to action are turned into avenues of delight.

It is in this respect that the basis and the ultimate appeal of all art is sensuous. We become engaged, as it were, by the amiable and intensified surfaces of things. The charm of a still life is certainly in its composition, but it is the blues and greens and yellows of the fruit that arrest us; our body becomes alive to what the senses present. Those moralists who have regarded art as a sensuous distraction have sourly stated the truth. Eyes dulled and routinated become keen again in the observation of

painting; the ear becomes a subtilized organ of precise and intense sensation. We move in painting and in music not among the abstract possibilities of action but among the concrete actualities of what is there to be seen and heard.

The arts do more, however, than simply intensify sensations. In the routine of our lives, successively similar situations have produced successively similar emotional reactions. We become dulled emotionally as well as sensuously. In the clear and artful discipline of a novel or a drama, our emotions become reinstated into a kind of pure intensity. It might appear on the surface that the actualities of life, the impingements of those so very real crises of birth and death and love, are more intense than any form of art provides. That is true. But we do not live always amid crises, and the ordinary run of our experiences gives us only emotions that are dull and thin. A tragedy like *Hamlet,* a novel like *Anna Karenina,* clarify and deepen for us emotional incidents of familiar human situations. For many people, it is literature rather than life that teaches them what their native emotions are. And ideas themselves, which in the abstractions of formal reasoning may be thin and cold and external, in the passionate presentation of poetry and drama may be-

come intimate and alive. Those would fall asleep over Godwin's *Political Justice* who might be inflamed to passion by the political poetry of Shelley. Whom the formulas of friendship enunciated by Aristotle leave cold, would be stirred to living emotion by dialogues gracious and humane in which Plato illuminates that amiable theme.

The second function of the arts noted above was the clarification of experience. This holds true likewise from the direct level of the senses to that of speculation and reflection. Our experience, through the pressure of impulses on the one hand, and the conditions of living on the other, is conventionalized into logical and practical patterns; we are likely to forget how diverse and miscellaneous experience in its immediacy is. It consists of patches of color and fragments of form; it lives as a moment transient and confused in a vanishing flux. Our senses, our instincts, and our world give some form to the undiscriminated blur. Were there no pattern at all to follow we could not live. Every blur of vision forms itself into some kind of landscape: the chaos of impressions and impulses at any moment has for that moment some coherency and shape. Our habits and our institutions canalize life. Even insanity has its own, if irrelevant,

kind of order. Except in drowsiness or semistupor, and hardly even there, absolute chaos does not exist.

But in works of art sensations are more profoundly and richly clarified through some deliberate and explicit pattern; emotions are given a sequence and a development such as the exigencies of practical life scarcely or rarely permit. Our reveries, amiable and wandering, are disciplined to the pathway of some controlled, logical sequence.

An illustration of each may be of service. Others than painters of still life have seen fruit in a bowl on a table. But it requires a Cézanne or a Vermeer to organize the disordered sensations of color and form into something lucid and harmonious and whole. Everyone has experienced the blindness of human pride, or the fatal possessiveness of love. But it requires a Sophocles to show him the tragic meaning of the first in such a play as *Oedipus*, a Shakespeare to exhibit to him the latter in *Othello*. Even the most unreflective have at some time or other harbored scattered and painful thoughts on the vanity of life or the essential beauty and goodness of Nature. A few have formulated these scattered insights into a system. But a poet like Lucretius can turn that vague intuition into a major and systematic insight; Dante can exhibit the

latter in a magnificent panorama of life and destiny. The kaleidoscope of our sensations falls into an eternal pattern; a mood half articulate and half recognized in its confused recurrence becomes, as it were, clarified forever in a poem or a novel or a drama. A floating impression becomes fixed in the vivid system of music or letters.

In a sense, therefore, all art is idealization, even where it pretends to be realistic. For no experience could possibly have the permanent order, the pattern, the changeless integration of a work of art. The mere permanence of a painting as compared with the vision of a passing moment, the mere dramatic logic of a drama as compared with the incongruous juxtapositions of life are illustrations of the point. But the idealization which is art has the benefit of holding a clarifying mirror up to Nature. It shows us by deliberate artifice what is potentially in Nature to be seen, in life to be felt, in speculation to be thought.

Now, to return to the interpretation of experience. Psychologists and logicians are fond of pointing out how much of what seems to be mere and sheer sensation is a matter of judgment and inference. We do not see cabbages and kings; we thus interpret blurs of vision. Our intelligence and our habits are, in their way, artists.

They enable us to respond to things not simply as sheer physical stimuli but as meanings. The fine arts simply accentuate the process or perhaps merely italicize the process which all intelligence exemplifies. Those separate spots of color become significant items in the total pattern in a painting, the pattern itself is significant of a face, the face of some passion or its tragic frustration. In a novel the words are significant as well as vibrant: they tell with significant detail of some life, some experience, some destiny.

All the arts in one way or another, to some greater or lesser extent, interpret life. They may "interpret" nothing more than the way in which a bowl of fruit "appears" to the ordered imagination of a painter. They may "interpret" nothing more than sensation. Or they may interpret, as *Hamlet* does, or *War and Peace,* or *Ode on the Intimations of Immortality from Recollections of Early Childhood,* the confused intuitions of millions of men, bringing to a focus an obscure burden of human emotion. A poem like *The Divine Comedy* or Goethe's *Faust* may be a commentary upon the whole human scene, its nature, its movement, and its destiny. When Matthew Arnold defined poetry as a criticism of life, he might well have extended his definition to the whole of the fine arts.

For criticism is a judgment upon, an interpretation of, a given section of life. Explicit interpretation, of course, is to be found chiefly in literature. But a statue by Michelangelo or Rodin, a piece of music by Beethoven or Debussy, is by virtue of its comprehensive and basic quality, its mood, its tempo, and its essential timbre, an interpretation of experience. One hears more than an arrangement of sounds in Beethoven's Fifth Symphony. One hears the comment of a great spirit on the world in which it lives. In Rembrandt's pictures of old rabbis, or El Greco's of Spanish grandees, there is more than meets the simply pictorial eye. These works are the language of men who not only saw and heard with the external eye and ear, but put into sound a hearing, into canvas a vision of what life essentially meant to them.

These three functions, intensification, clarification, and interpretation of experience, the arts fulfill in various degree. For many observers the arts are simply sensuous excitements and delights. For many they are the language in which the human spirit has clarified to itself the meanings of its world. For many the arts are the sensuously enticing and emotionally moving vehicles of great total visions of experience. The arts, in fragments as it were, suggest the goal toward which all experience

is moving: the outer world of things, the inner world of impulse mastered thoroughly by intelligence, so that whatever is done is itself delightful in the doing, delightful in the result. The Utopia of the philosopher of which Plato dreamed is foreshadowed in those moments of felicity which the fine arts at moments provide. A symphony in its ordered perfection, a drama in its tragic logic, a poem in its sensuously moving grace, is a foretaste of what an ordered world might be. Art is another name for intelligence, which in an ordered society would function over the whole of men's concerns, as it functions happily now in those scattered works we call beautiful, in those happy moments we call aesthetic pleasure.

# TWO

## ART AND CIVILIZATION

L ONG ago Aristotle pointed out that the meaning
of art could be best understood by contrasting it
with Nature. Art is human intelligence playing
over the natural scene, ingeniously affecting it toward
the fulfillment of human purposes. A complete civiliza-
tion, as has already been pointed out, would be coin-
cident with complete intelligence. Life in such a state
would be identical with art. The degree to which civiliza-
tion is disordered is evidence of the extent to which ran-
dom impulse and irrational habit still govern our actions
and dispose our lives. The arts of statesmanship and of
human society are still amazingly primitive. Prejudice,
guesswork, special interests, and phantom fears still
threaten for long to usurp the place properly belonging
to reason in social affairs.

But very early in the history of human affairs intelli-

gence came to take the place of mere animal response; art began to redirect and modify Nature. The breaking of a stick, the building of a fire, the domestication of animals, the sowing of crops, the construction of a hut, the digging of a cave—all these were interferences of man with the world as he found it. They were the rudimentary and essential instances of that art by which man first got himself food and shelter. In a broad sense, the key instances of art are to be found not in the concert hall or the museum, but in the field, the pasture, and the plow. In a world full of perils and uncertainties man had to learn to live before he could learn to live beautifully or bother, as it were, to create beautiful things. Yet as anthropologists deep in the study of primitive life have repeatedly pointed out, it is by no means clear that the necessary came before the beautiful, or that the essential preceded the merely decorative. It seems rather that in the very midst of doing what had to be done the primitive imagination found or made the leisure to add a gratuitous grace, a charming and unnecessary fillip. Pots and baskets were not only made but designed. Men not only dug themselves caves but made paintings upon their walls. The human artisan, seduced by the possible delights of color and line,

came to linger upon them; in primitive pottery and basketwork it is difficult to say whether the artisan and the artist are to be distinguished at all.

Yet whether historically the industrial arts preceded or came *pari passu* with the fine arts, analytically there is a distinction to be made. There are in contemporary civilization certain arts clearly servile, instrumental, and industrial in character. Under mechanical conditions of production, where the aim is quantity production and the method that of machines, art is a technique whose interest is in its results, not in production, and whose results are interesting for their utility rather than their beauty. The industrial arts thus serve our needs; they give us clothes to wear, houses to live in, motors to move in, bridges to cross, and ships in which to traverse the sea. If possible we would have all these things beautiful, and in a thoroughly reasonable civilization the houses would be charming to the eye as well as tight against the weather, the clothes would be beautiful to look at as well as proof against the cold, the ships would be arrows of grace against the sky as well as seaworthy carriers from port to port. There are a thousand reasons in the economic disorganization of our lives why all houses are not individually beautiful nor all bridges

monuments as well as roadways across rivers. Quantity production is one reason; the cheapness and standardization of machine methods is another. The emphasis in an industrial civilization on utility rather than grace is a third. But the bleak manufacturing cities of the north of England or of the United States are testimonies to, and instances of, a period of civilization when the separation between the beautiful and the useful was most aggravated and intense.

For instances of what are commonly called pure or fine art the imagination flies usually to a sculptured horseman among the Elgin marbles, a Greek temple shining by a Sicilian sea, a lyric by Shelley, or a quartet by Schubert. These things seem to have their own unquestioned charm. They bake no bread, but they feed the eye or the eye of the soul. They stir the senses to action and the imagination to pleasure and the mind to delight. They are good because they are good for nothing except their own immediately charming selves. Such value as they have is to be reckoned not in terms of the utilities they produce but the immediate sensuous and imaginative satisfactions they provide—for the colors, shapes, sounds, and suggestions they are.

These things, moreover, contrast with the method of

production of utilities in a machine age. Each of them bears the signature of the artist who produced it, though his name be forever anonymous. The signature is that induplicable temper and quality that distinguishes one artist's work from another, and distinguishes art altogether from manufacture.

The crucial difference between the fine arts and the merely useful or industrial is that the first provide instant satisfactions that are in an immediate sense present, while the latter provide the instruments for other satisfactions. One need not know about Greek religion, or certainly need not believe in Greek gods, to be stimulated and calmed by the presence to the eye of the sandstone columns of the temples at Girgenti in their symmetry among the olive hills and sea. One asks no questions of the good that will be accomplished by a sonata by Mozart, but rests absorbed by the sounds immediately and faultlessly satisfactory to the ear.

In the case of the industrial arts, the first question to be asked is whether a thing fulfills its functions, whether it will provide the ulterior satisfaction in the interests of which it was made. The bridge must safely span the river; the ship must be safe to cross the sea; the clothes must keep us warm.

# ART AND CIVILIZATION

There have been happy ages in the world when the division between utility and beauty was less acute; there are promises in our own age that that division is passing away. There are half a dozen museums in Europe which have whole galleries filled with the delicate paraphernalia of daily Greek life—vases, spoons, combs, jars, and shields. These things were all made for use; they were intended to serve a function. But to the nostalgic eye of the modern it is not their function but their decorative perfection that is of first interest. We see almost purely as things of beauty what to the Greeks who employed and to the Greeks who made them were things of daily use.

Again, the notable buildings of the Renaissance are churches and chancelleries and palaces intended for habitation. The medieval period produced churches that were at once works of art and places of worship. The stained glass windows of Chartres were the luminous enhancement of a shrine of the true faith. The sculptured portals were exuberant decorations upon the house of God and the center of His religion. What gives the aesthetic monuments of the Continent so rare and melancholy a charm for the modern is the fact that they are truly monuments and expressions of a civilization. What meets the eye of the tourist once served the needs of men. What

to the disillusioned skeptic is a monument of art was to the believing medieval a daily instrument of believed religion.

Such instances give point and substance to the contention that a healthy art is one in which there is no divorce between end and means, no split between the instrumental and the beautiful. Some arts, like architecture, can never quite escape into the purely aesthetic. Buildings cost too much to build and occupy too obvious space to be purely decorative piles. They must subserve some use, and part of their beauty is their appositeness to the function toward the fulfillment of which they were constructed. A cathedral, a college, and a prison, each has the character of its visual appeal determined partly by the social function it at once serves and celebrates.

But in the other arts, the divorce, especially in our own age, between the useful and the fine is more easily obtained and more characteristically sought for. The best illustration, perhaps, of this divorce, intentional and emphatic, is the movement called in the nineties "art for art's sake." The attitude that the arts are free of any social, moral, or practical obligation was part of the revolt against an industrialism that was giving us the factory town, and a materialism in thought that was robbing the

universe of color and glamour and spiritual value. In some chiseled form or tutored phrase, in the perfection, airy and irresponsible, of music, the disillusioned Epicurean spirit could find its momentary peace and its transient and inconsequent delight. The cult of a beauty without responsibility is a reaction against a responsible life without beauty. In the forms of art the emancipated spirit may find the satisfaction that is denied to it by a civilization without form or a universe conceived as without meaning.

It is easy enough to see where the division between the fine and the useful leads us. It produces, on the one hand, a practical civilization in which there is no interest in sensuous charm or imaginative grace, the Land of Smoke-Over celebrated in the legends of Mr. L. P. Jacks. It produces, on the other hand, the decorative trifling of the piddling little exquisites, the soft luxuriance of the aesthete whose dainty creations and enjoyments have no connection with the rest of life. Those fashionable art cliques so much despised by Tolstoy and so roundly condemned by him in *What Is Art;* those cults of words without meaning and music without order which spring up now and again, the lily white roses and the languors of the nineties—all these are symptoms of a society whose

art is a sporadic little nervous dissipation for a small group rather than the expression of a civilization, healthy and general, which flowers in the arts into imaginative expression.

It is because the arts have been so often "brief truancies from rational practice" that they have from the dawn of speculation been the subject of censure and contempt by widely differing groups of persons. The chief vials of wrath have been poured by the moralists. To men intent upon the serious concerns of alleviating the distresses and disorders of human life, the arts have always seemed distractions from the serious business of living, and sensuous disturbers of the spirit. Plato, himself the most poetic of philosophers, was the first on moral grounds to condemn the poets chiefly, and hardly less so the painters and musicians. He pointed out what moralists since his day have never failed to repeat: that the arts could disturb the established order of men's thoughts and actions; the creations of a poet's dreaming could divert men from the compulsive actualities of their lives. Moreover, the soft luxuriant strains of music could quell or qualify their martial ardor. The fantastic "imitations" of the painters could divert men from the unimpeachable forms of authentic reality.

Other moralists, among whom may be listed St. Augustine, have concentrated on the sensuality to which the arts might turn men. Moralists, like aesthetes, have been conscious that the chief suasion of the arts came through the senses. The attention and the imagination of men were arrested at the engaging physical surfaces of things. They made men pause over the glories of earth, as St. Augustine points out, instead of remembering the glories of its Creator. Now the distinction between sensuousness and sensuality is a delicate one. The love of color and form and the form and color of love are not easily distinguishable. The flesh incited by beautiful objects is still the flesh, and the incitement may not pause at detached and inanimate aesthetic objects. Who knows (moralists like Plato and Tolstoy have felt) where the senses, awakened, may not lead their enraptured possessor? If philosophy was by medieval theologians conceived of as the handmaid of theology, the arts have often been conceived of as the handmaids of the devil. Sensuous beauty was but the amiable pathway to the soul's destruction.

Part of the indictment of the fine arts on the grounds of sensuosity is at least intelligible. The moralists have always paid, as it were, a reluctant tribute to the power of an art over the stimulated and absorbed senses of man.

And long before psychoanalysis made familiar the sinu-
ous and pervasive radiations of sex, Christian moralists
realized how closely the senses are overlaid with a veil of
sexual feeling. To become sensuously alive was to be also,
if only incipiently or subconsciously, sexually awakened.
Much of that glamorous intensity which goes with aes-
thetic experience is undoubtedly sexual in some of its
elements. Much of the release and intoxication in the
Dionysiac aspects of art are clearly sexual in character.

The materials out of which the moralist makes his in-
dictment are therefore plausible and accurate. But the
inferences he draws are more dubitable in character. To
a generation at least that has given up passing beyond the
flaming bounds of the world to a realization of the pos-
sibilities of life here and now, the accusation that the
arts are sensuous in their appeal loses most of its sting.
"What are we given, what do we take away," Masefield
asks somewhere, "five little senses startling with de-
light." Every canvas or musical composition that can
awaken us more exquisitely and accurately to the infinite
and various surface of our experience does that much to
sharpen life and render it thereby more alive. If part of
the aim of an ordered civilization is to prolong life, cer-
tainly part of its ambition is to variegate life and fill its

moments with the quality of living. To be sensuously dead is to be on the way to death in toto. A subtilization of sensuous response is a subtilization of the whole temper and fiber of being. Flights of the spirit are perhaps better to be looked for in persons whose senses are stinging and alive than in those who go about dead to the colors of that world in which their spirit lives and has its being.

The traditional fear of the arts as panderers to sensuality never received more emphatic, eloquent, and uncompromising voice than in Tolstoy. But to fear the arts because their subject matter or the basis of their appeal is partly sexual is to fear an impulse which modern insight refuses to regard any longer with pretended horror or suspicion. That refinement of feeling, affection, and thought which is the aim of most moral systems begins with the senses, and it is to the refinements of sensuous experience that the arts are in the first instance addressed.

There is a subtler way in which the arts have become suspect. The Puritan objects on conventional moralistic grounds. But the Statesman objects on the grounds of policy and on the basis of peril. It is to the interest of the Statesman to keep if not the established order, to keep at least some order. One of the characteristic features of the

arts is to teach its connoisseurs continually to see the world and experience in new and hitherto undreamed-of patterns. The Puritan objects because of the sensuous appeal; the Statesman because of the imaginative power of the fine arts. The imagination of the poet is compacted of things that never were on sea or land, fairer far than the order of things as he finds them in the conventionally real world to be. The poet is, as Plato was the first to perceive, a born revolutionary. How could the order of things as he finds them in a London slum or a London suburb compare with the range of a Shelleyan imagination dreaming of a city of good order and loveliness and light? Milton begins to justify the ways of God to man, and ends by raising questions that make one sympathize imaginatively with Satan. And a work of art may become a devastating piece of propaganda; the *Sorrows of Werther* may bring out a wave of suicide; *Uncle Tom's Cabin* may incite a movement toward the freeing of a race. The Statesman has always been aware how the artist, through an imaginative touching of the passions of a nation, may destroy the long-standing pillars of habit, the ancient discipline of institutions or of reason. The Statesman with his laws has feared the poet with his songs, or the dramatist with his passions. The censor has

risen time and again in civilization to check not simply the sensual but the political perils of a seductive art.

The artist himself, when he is anything more than a perfumed aesthete, would be the last to deny the moral power and imaginative effectiveness of his medium. Plato himself recognized them and because he recognized them thought only those tales should be told, those songs should be sung which persuaded men to the pattern of what he conceived to be the Perfect or Ordered State. "Poetry," wrote Shelley in his passionate defense of his art, "is the unacknowledged legislator of mankind." It is a myth, not a mandate, a fable, not a logic, a symbol rather than a reason by which men are moved. In any re-ordering of the world nearer the clarified heart's desire, it will be the images and symbols of the arts by which the hearts of men will be moved and their actions therefore directed. The imagination will affably teach them to perform that which the formulas of reason would never persuade them to undertake or endure. In the possible ultimate economy of reason it is the voice, clear and pleading, of the arts that will be a moral agent. It is precisely because they have imaginative power that the arts have moral dignity and importance.

The Puritan has condemned the arts because they are

sensual; the Statesman has time and again condemned them because their unlicensed dreams are precipitates to the dangerous or the fantastic. A third characteristic objection to the fine arts has come from the Practical Man, who sees in the creation and enjoyment of the fine arts a futile relaxation and an unprofitable felicity. The arts are by the efficient men of the world regarded as "escapades in tutored dissipation." Men of the world, the heads of families, of businesses, and institutions have always regarded with more than suspicion the artist who feels no responsibility to anything save his medium, the aesthete who feels no interest in anything but his exquisite sensations. In a world where there is much to be done merely to keep that world going, where the cares and compulsions of affairs tax the energies and exhaust the ingenuities of the most robust and ingenious of men, the arts, both in their creation and enjoyment, seem fantastically trivial. The care of a child seems more substantial than the fabrication of a sonnet, the building of a great institution more permanent than the tiny splendor of a cameo. On the side of appreciation, likewise, the canvas of the world seems more interesting and robust than any scene on canvas; the passions and complexities of affairs more arresting than any fictitious complica-

tions of literature. Compared with life, from the point of view of the Practical Man, letters and music are thin afterechoes. At commencement addresses lip service is paid to the Muses, but in their hearts, practical men have always treated the arts as trivial and effeminate.

"Art bakes no bread," is the substance of this indictment, and that man cannot live by bread alone might be said to be the substance of a just reply. The objection of the Practical Man consists in his shrewd perception that the arts constitute, as it were, the playtime of the race. They are enjoyed for their own sweet sakes, not for their consequences. In music, letters, and painting, we bask in the immediate and grateful sun of perception. The moralist is engaged in righting the wrongs, in rectifying the conduct of a disordered humanity. The Practical Man is engaged in building up the palpable materials and efficiencies of living. The artist is indulging simply the play of the virtuoso, enjoying the free incarnation in matter of some winning image in his mind. The aesthetic observer is indulging simply the pleasure of a sensuous and imaginative absorption in what is set before his senses and imagination.

From a practical point of view, there might seem to be nothing more futile than the fine arts. A Beethoven

sonata does not in its making produce a revolution in industry and politics, nor does its hearing in any immediate or detectable sense affect the character of the individual or of the city in which he lives. The artist, working apparently by fits and starts, does not fit into the schematic efficiency of practical affairs. The observer, with his absorption in the little delicacies of aesthetic perception, might seem to be spending time better employed in the important work of the world.

But it is precisely on the question of importance that the objections of the Puritan and the Practical Man turn out to be those of the uncomprehending Philistine. For upon examination, it turns out that the arts in both their creation and enjoyment are symbols of precisely that Good Life which the moralist is implicitly engaged in making possible, that felicity toward which all the instrumentalities of the Practical Man are directed.

It has been pointed out endlessly that where human beings were completely adjusted one to another, there would be no occasion for moral casuistry or speculation. Were the earth a Paradise where all that we needed were already added unto us, there would be no call for industry or practical work. We think about what is good because we are enmeshed in evils; we are engaged in practical

affairs because, as it has aptly been phrased by Mr. Horace M. Kallen, "we are born into a world which was not made for us, but in which we are willy-nilly compelled to grow." For what would be left for a society in which all the grosser conflicts were resolved, and all the grosser necessities provided? How would the human spirit occupy itself freed of the entanglements of a disordered society and from an onerous preoccupation with the provision of material things? We have a glimpse of the answer to that question in the use of leisure where the pressure of affairs permits it. The goods that men genuinely cherish are best recognizable in the choices of activity they make, in the preference of enjoyments they consume in their hours freed from a compelled routine. The good life, of which moralists talk so much and often seem really to care so little, would, as Aristotle long ago observed, be a life excellent in the sense of being a realization of all life's possibilities. The subtle enjoyments of refined sensuous perception, the harmonious realization of our needs and capacities for emotion, the pleasures of free speculation, these would fulfill always, as they fulfill now at moments, the lives of rare and fortunate men. And since man is something more than a mere sensorium, since experience consists in doing as well as undergoing, even

53

where nothing had to be done, men would certainly be engaged in doing something. What they would do would, within the limits of their capacities, be a kind of art. They would let their hands, voices, and minds play spontaneously over the materials at their command, as the hands of the virtuoso play over the keys of the piano. Their living would be at once disciplined and free. The freedom would be emancipation from ulterior motive; the discipline would be that autonomous control which makes possible the spontaneity of the virtuoso.

Aesthetic enjoyment and artistic creation are anticipations in our civilization of what the Good Life would really be. Such happiness as is present among our contemporaries is the happiness of those who are doing work that is itself delightful to them and enjoying things that are themselves a delight. The *Paradiso* of Dante consisted in a constant vision of God and the Good. But even the angels must do something, if it be only singing. The image of a perfect society is not that of aesthetes in a museum but of artists at their work. The function of the arts in civilization at present is largely that of a dilettante escape for the observer, a truant absorption for the artist. In a rationally ordered society, all work would have the quality of art, all enjoyment would have the imme-

diate and glamorous character of aesthetic appreciation.

To say that the arts are impractical and irrelevant is simply to comment on how far we are this side of Paradise. The distinction between work and play is a symptom of the confused state of our society and of our souls rather than of the eternal nature of things. It indicates how much without quality and without pleasure are the stable activities of our civilization, how detached and trivial are our aesthetic enjoyments. In the Middle Ages, in a thousand ways so tragically more unhappy than our own, craftsmen had at least the joy of individual creation. They were not numbers in a factory tending a machine. In Greece, the dark shadows of whose shining life we tend to forget, for a small class at least, the present was enjoyed for its own possible exquisite sake.

The pleasurable activities of the artist, the pleasures of appreciation are both indications of what a sound and happy social order would make more generously and pervasively possible. Work, to a far more general degree than at present, would be art. It would be the happy use of spontaneous faculties in the creation of things positively pleasurable in their product, agreeable in their production. Work would be play. But play, especially the play of aesthetic production, would cease to be trivial.

And as for that detached aesthetic enjoyment which constitutes the pursuit of the aesthetical dandy at present, that would likewise be transformed. Painting and poetry and music would not be the dandiacal privilege of a small leisure class, but the universal enjoyment of a widely present intelligence, no longer too calloused by meaningless work to be capable of sensitiveness and appreciation. The measure of our civilization is exactly to be estimated by the extent to which its characteristic activities have the quality of art, its characteristic enjoyments have the free and stimulating peace of enjoyment. In time the disciplined freedom of art may come to be considered the highest morality; the creation and enjoyment of art the most rational practice. But at that time the arts will include the art of life, and in such a society statesmen would be the major artists.

There remains to be noted, among the functions of art in civilization, what might be called the metaphysical revelation in aesthetic experience. Philosophers have for some thousands of years now been concerned with an inquiry into the nature of Truth and the substance of Reality. The pursuit of truth has always been regarded as one of the most disinterested and laudable of human enterprises. The human consciousness has always been

uneasily curious as to what was really real. Now the nature of truth is a logical inquiry; the inquiry into the nature of reality may very likely turn out to be primarily an aesthetic enterprise. Truth is always propositional; it is a statement about a fact. But facts are data of immediate experience, and it is the special privilege of the fine arts to reveal immediate data with a clarity, intensity, and purity that promotes them as it were to a special degree of reality. That half lethargy, half confusion which is the ordinary run of our experience blinds us to the "realities" about us. The artist opens our eyes and our ears and our imagination so that what he writes or paints or composes comes to have more "reality" for us than that clouded actual environment in which we walk and breathe. The "things" in a painting have more purity and precision and intensity than the things as seen by the routine practical eye. The characters in a novel have more urgency and clarity than the people we brush against in our hurried daily contacts. The place to seek for reality is not in some metaphysical formula, but in the unimpeachable realities in works of art.

It was something of this nature that Bergson realized when he told us that the intuition of the poet is a surer revelation of reality than the analysis of the metaphysi-

cian. It is this that Croce means by insisting that the whole function of the artist is subsumed under the word "Intuition." The philosopher may talk analytically for a volume about immortality, but a stanza of Wordsworth or a myth of Plato may place us in the near presence of the beautiful thing itself. A picture by Cézanne of a snow-laden tree among fallen snows may give us for the first time an inexpungeable sense of the reality of a tree. Anna Karenina may become more real to us than a thousand women of our acquaintance. That unique and individual flavor which distinguishes reality from its shadow may very well turn out to be found among those comparatively phantom objects known as works of art.

# THREE

## THE WORLD, THE WORD, AND THE POET

THE artist works always in some material; he builds with stone, with color, or with words. But the art of words, especially as the poet uses them, is one of the most curious and crucial problems in any theory of art. Language is, in one of its aspects, the most practical of human instruments; it is the indispensable means of communication between human beings in their daily and material affairs. Considered without reference to its meaning and its practical and logical bearing, however, it is the most airy and substantial of media. It is as vibrant and transient as music, and the poet must build with materials compared with which the color and line of the painter are monumental and enduring. All literature, but more especially poetry,

may be regarded, therefore, as a hybrid art. It is in one sense a music whose effects happen to be limited to tones and melody, a music which restricts itself to the sounds that happen to be incarnate in the words of some particular language. Or it may be regarded as a form of communication in which there is a diverting or intensifying musical effect. But its fundamental character is that of an incidentally moving and imaginative form of communication.

This double direction of poetry, on the one hand, toward a pure art of sound, on the other hand toward a pure art of communication, indicates the duplicity, as it were, of language and the bifurcation toward which all literature is from the outset committed. Language remains at once practical and musical, logical and melodic. Literature is fated therefore, at the outset, to go on two tangents, one poetry and one prose. Ideally speaking, prose to become the unqualified fulfillment of its special function should become a kind of telegraphy or algebra. It should be the barest and most unequivocal conveyance of what it is intended to convey. It should be the unmistakable symbolism of its unimpeachably clear intention. Its perfection is, strictly speaking, in the language of

science. Logically considered, it has no business to be an art at all.

But words have two aspects which keep prose a medium, though a treacherous one, of art. For all that the most fastidious logical precision may do to shear words of anything but their bare logical intention, they retain overtones of feeling, and remain tones or sounds. Even an algebraic formula has an inescapable rhythm; even the prose of philosophical analysis remains inescapably true to the genius of its particular language. The prose of Descartes has the peculiar and memorable cadence of French; Bergson is good to read, among other things, for the sound of what he says.

Words, moreover, are not merely tones; they retain overtones of feeling. They are colored and qualified by all the associations of the circumstances of their learning, by the whole flavor of the childhood conditions under which they were acquired, of the human situations in which they are used. Language never really does become pure algebra, except in the purely technical jargon of some esoteric scientific inquiry.

Words are never indifferent vehicles of indifferent meanings. What they signify is attractive, like "home,"

or repulsive, like "death." And words whose meaning may be indifferent in themselves are confused deliciously or perturbingly with a thousand half-conscious associations.

It is because words have this equivocal status, being at once musical sounds, logical symbols, and emotional provocations that the hybrid art of prose is possible. For the most part, prose neglects, save in purple patches or deliberately "fine writing," the purely euphonic and melodious possibilities which poetry specifically exploits. The special virtue of prose, as Arthur Clutton-Brock points out in *Modern Essays*, is "justice," a nice adaptation of the medium to what it has to say. The special province of prose is determined by the fact that it can exploit the representative and communicative aspects of language. It can tell a story, explain a thought or a situation, describe a place or a person, argue a cause, expound, plead, convince, narrate, persuade. It can render the whole of human experience. It has at its disposal not merely the obvious or precise meaning of a word, but its overtones and suggestions. It can borrow from its sister art, poetry, the incidental effects of music. But because it has so wide a field of significant communication, the art of prose ceases to be merely an artifice of language. It

becomes the incidental instrument of an imaginative synthesis, a fictional or created world. Its chief field in our own day is the field of fiction which we shall have occasion briefly to consider at the conclusion of this chapter.

The art of poetry is more specifically an art where the medium of language is itself in the foreground, and where not the poet nor his hearer nor his reader ever quite forgets the language in what is being said. The poet is, as Santayana somewhere says, elementally a goldsmith in words. He arrests the attention of the reader as he is himself arrested by the sensuous qualities of the sound of words. One thinks indeed at times that it is almost a special concession to a poet, for example, to be born to the Italian language. It is, one almost imagines, impossible not to be a poet in a language where one can hardly ask the time or order a meal, save in a liquid cascade of vowels. There are lines of Shakespeare one remembers not least because the syllables melt mellifluously in one's mouth, "Bare ruined choirs, where late the sweet birds sang." Poets like Swinburne, seduced by the musically euphonious possibilities of sounds themselves, sometimes do not refrain from writing what is almost nonsense for the beautiful succession of sounds the nonsense makes.

It would be possible to conceive an art of poetry that

should be an abstract architecture of exquisitely chosen vowel and consonant sounds as meaningless and absorbing as the colors in an oriental tapestry. There are poets, as there are readers, whose ears have this preternatural sensitiveness, for whom the color of a sound has the same seduction that the color of a leaf or a lake has for more visually minded persons. "Cellar door," remarked a foreigner who had no knowledge of the meaning of English words, "is the most beautiful word I have heard in the English language." There are English poets who would have understood what he meant.

But the filigree work in words is obviously not the whole of a poet's function. An artful arrangement of consonants and sounds is clearly not the whole of the poetic effect. It is not the whole even of the sensuous effect of poetry. For language resembles music in another way than simply in the fact that its syllables are like the separate tones of music. Just as separate tones do not constitute music, separate syllables, however liquid or chiseled, do not constitute poetry. The human voice has inevitably a rhythmic beat, and all language is inescapably cadenced. It is the cadences of a language, as well as its separate syllables, that a poet exploits among the physical resources of his art.

64

# WORLD, WORD, AND POET

The rhythm of poetry may perhaps be defined as its special instrument of hypnosis. There are profound reasons, lying in the physiological nature of life itself, in the beat of the heart, in the very act of breathing, why the human imagination as well as the human ear should be so susceptible to the effects of rhythm. In music, these effects are explicit and obvious; in poetry, they constitute the special imaginative atmosphere, so to put it, in which the poet throws the reader, in which what the poet has to say is said. A poem is a dream or mood, a large or little vision of experience, expressed with all the musical resources of which a poet is capable and with all the sudden revelation of "happy epithets," which is his special inventive gift.

But the large and loose rhythms of Walt Whitman, the tight and steely couplets of Pope, the languorous long lines of Swinburne, the organ sweep and crescendo of Milton's blank verse, quite apart from anything said or anything else in the manner of the saying, determine the effect and the appeal of the verse.

The basic movement of the rhythm, the total character of the dream, through the vehicle of exquisitely chosen sounds and incisively revealing epithets, constitute the poetic effect. But what does one mean by the

poet's dream? Not a small share of the nature of poetic creation and appreciation is involved in the answer to that question. For a poem is more than its separate syllables, its rhythms, its words, or its meaning that might be translated or explained. It is a total creation, an organism in itself, whose gestation is somewhere deep in the subconsciousness of the poet and whose being is that of a dream immortalized upon a page.

We know much too little to say by what alchemy or fermentation the thousand images, agonies, joys in a poet's memories become transmuted into the living whole that constitutes a finished poem. If we did know that, we should know the secret of many other kinds of genius beside that of the poetic. "Poetry," says Wordsworth, "is emotion recollected in tranquillity," and in so saying he indicated one quality of the total residual effect of any poem that is something more than verse. For the poem as a dream is a combination of images, insights, and ideas fused into one whole through some unifying mood. The sonnet, "The world is too much with us, late and soon," may be translated into expository prose as an idea, a thesis. It tells us what many moralists have said less memorably, that the pressure of things and events and affairs corrupts that capacity for pagan joy in the fresh

world about us that is our birthright. But the effect of the poem, and what might be called its life, is not in the sentiment thus uttered, nor in the separate syllables added together. No transcript of it will do it justice or represent it. Its effect is the subtle communication of the poet's mood or dream, his synoptic vision revealed in our own consciousness. A bit of the world seen, a bit of life experienced, a personal sorrow or a universal joy are transformed in the alembic of the poet's being into something that is not simply a sonnet on a page but a living organism in eternity.

Now that total residual effect which makes the impression of something Platonic and eternal and living as over against any of the separate elements that enter into it, we have called the poet's dream. It is the communication of that dream that is his essential business. And for its communication, if any single element is to be thanked, it is that of rhythm. The word "hypnotic" has often been used about poetry, and we speak lightly of "poetic magic." Both the words are peculiarly apposite.

The magic may be said to lie in the evocative epithet, in that enumerative loveliness which is one of the chief charms of the poet's vocabulary. The hypnosis lies in that compulsion into which any rhythm throws the at-

tention. We are attuned to a given mood, our life flows with the current of a given cadence. That is one reason among others why a poem leaves us with something more than can be summed up in its elements. We have shared for a moment in the life of that organic dream which is a poem. Its pulse beat is one with our own. Anyone, indeed, who has ever written poetry knows how a poem often begins in the mind as a kind of cadence with a hardly specified meaning. Many a poem in the history of English literature has begun as a song without words that hummed itself in the poet's imagination and gradually took form and words and meaning. Any lover of poetry knows that below the particular sounds and specific meanings what he loves and responds to is the "element of song in the singing, the numbers as they flow." The rhythm may be obvious and banal as in that verse that haunted Mark Twain, "a blue trip slip for a three cent fare," or may have all the subtle variation of the blank verse of Milton. But the basic heartbeat of poetry is gone where there is no singing; the words may be memorable or clever; they will not, unless they have the hypnosis of rhythm, sing themselves into the reader's heart and become, during that experience, his life.

The qualities, liquid and euphonious, the march and

suasion of rhythm are not by themselves sufficient to account for the effect of poetry. For if poetry were simply tones and syllables and melodies of words, it would be a music limited by the sounds and combinations possible in a language and lacking that variety of individual sound and of multiple and complex harmony possible to music. Poetry may be, as certain poets have wished it to be, pure music, but such a music, compared with music itself, would be thin as well as pure. It needs no elaborate demonstration to show that poetry is composed of words and that words not only sound but speak. The significance of words can never quite be obliterated, and the poet would be wasting one of the chief resources of his art if he neglected to exploit the specifically verbal quality of words.

Now a word has at once a logical intention and a psychological connotation. It is upon this duplicity that the poet's art partly depends. But the poet is interested in precisely the penumbra of words which it is the business of the scientist to neglect. It is the power, above all, not the truth of words that is the poet's concern. A poet tries to render experience alive, whether it be sensations, his own moods or those of other people, or ideas. The poet wishes to celebrate the world, to render its vivid-

ness and impact, to communicate what has awakened his senses, stirred his emotions, or provoked his ideas. He chooses those words or those uses of words, therefore, that will induce in the reader a certain psychological state rather than merely communicate images, emotions, and thoughts to him. "England" in a diplomatic code could be represented by the symbol X. But England in Shakespeare's descriptive phrase, "This earth of majesty, this seat of Mars, this other-Eden, demi-paradise," is more than a logical character. It is a psychological provocative; it has all the magic and seduction of all the habits, childhood associations, racial memories that are in the imagination of a reader associated with the sound of the word. Words in poetry are not mathematical symbols but emotional provocatives. They speak not only *of* things but *to* the awakened spirit.

The poet is indeed chiefly engaged in awakening the torpid imagination by the liquid loveliness of sounds, by the march of his verse, but not least by the evocative words he uses. Those evocations depend most simply on his choice of words that will break up our abstract and conventional formulas for experience into the sensuous elements in which experience comes to the fresh imagination of the child. He will fill his verse with the concrete

and specific sensuous detail; he will enumerate the colors, smells, tastes, and touches of that world which has become to the hurried and practical adult a routine. One of the most brilliant instances of this aspect of the poetic art is Rupert Brooke's *Great Lover,* in which the effect is simply that of an exquisite commemorative reminder of those tense and tingling moments of sensation which in health and in youth we enjoy:

*"These I have loved:*
> *White plates and cups, clean-gleaming,*
*Ringed with blue lines; and feathery, faëry dust;*
*Wet roofs, beneath the lamp-light; the strong crust*
*Of friendly bread; and many-tasting food;*
*Rainbows; and the blue bitter smoke of wood;*
*And radiant raindrops crouching in cool flowers;*
*And flowers themselves, that sway through sunny hours,*
*Dreaming of moths that drink them under the moon;*
*Then, the cool kindliness of sheets, that soon*
*Smooth away trouble; and the rough male kiss*
*Of blankets; grainy wood; live hair that is*
*Shining and free; blue-massing clouds; the keen*
*Unpassioned beauty of a great machine;*
*The benison of hot water; furs to touch;*
*The good smell of old clothes; and other such—*
*The comfortable smell of friendly fingers,*
*Hair's fragrance, and the musty reek that lingers*

*About dead leaves and last year's ferns. . . .*

> *Dear names*
*And thousand other throng to me! Royal flames;*
*Sweet water's dimpling laugh from tap or spring;*
*Holes in the ground; and voices that do sing;*
*Voices in laughter, too; and body's pain,*
*Soon turned to peace; and the deep-panting train;*
*Firm sands; the little dulling edge of foam*
*That browns and dwindles as the wave goes home;*
*And washen stones, gay for an hour; the cold*
*Graveness of iron; moist black earthen mould;*
*Sleep; and high places; footprints in the dew;*
*And oaks; and brown horse-chestnuts, glossy-new;*
*And new-peeled sticks; and shining pools on grass;—*
*All these have been my loves."* *

One of the glories of English poetry, of any poetry, is that childlike freshness of sensuous impressions which the poet renders in his verse. Homer is compacted of such shining and immediate impressions; so is Keats, and, among so many more complex glories of his poetry, is Milton. The poet recovers for us through the choice of wakening epithets the glamorous surface of things. He names beings by their sensuous edge, the wine dark of the sea, the gray-eyed Athene, rosy-fingered dawn, the

---

* From *The Great Lover* in *The Collected Poems of Rupert Brooke*, New York, Dodd, Mead and Company, 1923.

touch of furs, the smell of old clothes, the feel of friendly fingers, the smell of the rose or the sting of its thorns.

One might say almost that it is the business of the poet to forget much of what usually concerns us in our reactions to things. He must recover, where he is successful he does recover, for us the immediacy of sensations such as a child has before it has been deprived of the innocence of the eye and ear and has learned to live and talk in secondary formulas and relations. Just as the child calls the train a "choo-choo," specifying it by its audible impingement upon him, so the poet reminds us by a thousand devices of felicitous names of what the world is to the unembarrassed and uncomplicated senses.

In order to achieve this function of sensuous celebration, the words a poet uses will be simple, sensuous, and passionate, but above all sensuous. For poetry that leaves the senses cold will not address itself easily to the passions. But the sensuous celebration which is poetry is not attained simply by the use of sensuous words. Too many of these have become dulled and colorless through routine use. The poet startles us into fresh recognition by an unexpected and dazzling association. A sixteenth-century poem on the Eucharist says:

*"The modest water saw its God and blushed,"*

and that surprising association makes us see with greater sensuous vitality the very act of the water turning into wine.

Books may and have been written on the use of simile and metaphor. The sense of the matter may be quite simply stated, however. Metaphor and simile are devices by which, through breaking up our routine associations and substituting novel ones, our experience becomes refreshed, vivid, and keen. But the use of metaphorical association is not simply to restore sensuous glory to things, but to give them life by associating them with our passions, our hopes, our fears, our traditions, and desires. Or, inversely, some emotion may be rendered suddenly living by giving it sensuous associations:

*"My love is like a red, red rose,"*

or

*"Du bist wie eine Blume."*

Or again, Rupert Brooke in his magnificent sonnet called *The Dead* tells us of the dead, first, explicitly, in terms of the life and beauty, "flowers and furs and cheeks," they had touched and loved. Then without comment he says:

74

*"There are waters blown by changing winds to laughter,*
*And lit by the rich skies all day and after,*
*Frost with a gesture stays the waves that dance,*
*And wandering loveliness; he leaves a white*
*Unbroken glory, a gathered radiance,*
*A width, a shining peace under the night."*

The living are at once assimilated to all those gay and dancing waters we have seen by day; the dead to calm, still waters we have seen in peace at night.

Metaphor and simile are the poet's rebellion against routine impressions. The moon ceases to be an unmeaning white disc and becomes "Queen of the Night." The sun is a young god driving his chariot across the sky. Beauty is "a candle clear in this dark country of the world thou seest." "The soul of Adonais like a star beacons from the abode where the eternal are."

Ultimately all language is metaphorical. No discourse can ever do more than suggest or symbolize in the most roundabout fashion what is actually experienced. But by the choice of sensuously vivid words, by the association of our impressions with our passions or of our passions with our impressions, poetry comes nearer, perhaps, the heart of the matter than any other kind of language.

It is for this reason that one cannot ever say exactly what a poem means or ever exactly or wholly translate it. As well try to render the taste of a pear or the feel of the skin of a peach against the skin. The music that gives a poem its atmospheric condition, the words that are its specific elements and give it its induplicable context, the metaphors that heighten the intensity of what is being actually suggested, all these are lost. The poem is the Word become Flesh or perhaps better still the Flesh become Word. The World becomes translated into the Logos of the poet, and in that incarnation in a musical and pictorial speech the World becomes real to the awakened and entranced reader.

The poet like a child loves the colors and shapes of things, and a whole anthology might be produced of poems that did nothing but in one way or another "commemorate the rose."

But the poet, for all his child's freshness, is not a child. He has refinements of feeling, complexities of mood that no child could possibly experience, and it is part of his art to render moods and emotions alive and real and communicable and in something like the same way and by the same artifices by which he vivifies sensation. Poetry is often identified with sentiment, not to add sentimen-

tality, because so much of the subject matter of the world's lyrics is the expression of personal emotion. That the themes of poets should be recurrently birth and youth and the doomed beauty of things is simply enough to be attributed to the fact that poets are human and share characteristic human emotions. Their poems on these themes are vibrant and memorable, however, not because their themes are universal or commonplace, but because their expression, in each case unique, has rendered with immortal poignancy some cherished or inevitable human mood.

> *"Oh, never say that I was false of heart*
> *When absence seemed my flame to qualify,*
> *As easy might I from myself depart,*
> *As from my soul which in thy breast doth lie."*

Thousands of inarticulate men and women have felt that emotion about their beloved, but in that sonnet of Shakespeare's they find their common emotion rendered with uncommon and vitalizing felicity. A poem of love may teach them by its own instant and luminous reality what the reality of their own love is.

In the province of emotion, indeed poetry is a more adequate discourse than any other form of utterance.

77

What in practical or logical contexts is negligible or distracting becomes central for the poet. Not the chemistry but the sparkle and glow of water, not the matter of solar distance but the fertile benediction of the sun concern him. Those emotional overtones of contacts with things or humans that the scientist or man of affairs must as scientist or man of affairs ignore, the poet deliberately cultivates. Just as a poem sensuously dead is no poem, so is a poem devoid of passion. The incitement to the subject matter of the passion may be very various; it may be the mysticism of Blake, the tortured amorousness of Donne, the love of God of Dante, the revolutionary or Platonic idealism of Shelley. But what starts that ferment of images and music, which is the beginning of poetic creation, is some intensity of living, some depths of passionate feeling which the poet wishes to utter, and, though he may not realize it, to share. Tolstoy in *What Is Art* ranks sincerity very high as an aesthetic virtue. But Tolstoy's was a moral conception of sincerity. In purely aesthetic terms, too, sincerity is a virtue. Some ardor must infuse the poem, and the technique is concerned with devices that make that ardor relived by the reader.

The poet may be passionate about things, about persons, about ideas. For ideas, too, as those forget who

have never had them or have ceased to have them, are experiences. And ideas may, through the art of the poet, come, as Hegel said, "to have hands and feet." Wordsworth's heart "with pleasure fills and dances with the daffodils." But ideas, too, may set the heart to dance. Vaughan writes,

> *"I saw Eternity the other night*
> *Like a great ring of pure and endless light."*

There is a whole metaphysical school of poets in England, there are poets from Lucretius down to Edwin Arlington Robinson, to whom and in whose poetry ideas are vivid and imageful and musical as a flower or a young girl.

There has long been popularly supposed to be a quarrel between philosophy and poetry, between the analytic interest in ideas that is the thinker's, and the preoccupations, passionate and sensuous, of the poet.

One need not, however, go further than Plato to realize how warm and immediate ideas may become. An idea may be communicated not simply in a formula but in a myth or a metaphor. It may be so expressed in terms of a sensuous image as in Plato's myth of immortality in the *Phaedrus,* the chariot of the soul in its eternal cir-

cuit of the heavens. It may be taught in terms of its passionate consequences, as Lucretius, hating religion, traces the glamorous freedom and emancipation of a materialistic view of life. Anything, great or small, sensuous or abstract, may stir the poet's imagination. If his imagination be wide and deep enough, he may turn, as did Lucretius, a vision of the nature of things into a comprehensive epic, whose greatness resides at once in the nobility and intellectual grandeur of its theme and in the music and passionate imagery in which it is expressed. Rarely enough, it is true, is the mind inquiring and free, joined to that peculiar rhythmic inventiveness and pictorial invention which are the poet's peculiar gifts. When these talents, rare in isolation, are joined together, the result is a poem of such simultaneous passion and scope as is *The Divine Comedy* or *On the Nature of Things* or *Paradise Lost*. In our own age, too, a poet might arise who would be able to turn the whole complex version of things and of fate which is gradually being framed by contemporary science into a poetry imaginative, sensuous, and comprehensive, calculated at once to provoke the intellect and stir the imagination of our contemporaries. There is no poetic subject matter *per se;* there are only poetic gifts. These may be lavished on a rosebud or

universe. It depends on the range of imaginative experience of which the poet is capable.

The art of prose takes us into a different realm at its periphery, though there is a common territory where it is difficult to distinguish its territory from that of poetry. At its extreme form, as has already been pointed out, prose is an art where the language *per se* is instrumental and incidental, where what is said is of incomparably more importance than the manner of its saying. At its extreme form, in other words, prose ceases to be an art at all, and is a bare means of communication. It is a system of practical signals, a telegraphy, or a system of economical formulas, a science.

At the poetic periphery of prose, it would be difficult to assign precisely the distinction between it and its sister art. Prose, too, has its purely linguistic and purely musical elements which no born writer or reader can fail to note or to cherish. Prose, too, in a sensitive stylist, exploits, though not perhaps as showily, the beauties of mere vowels and consonants in juxtaposition. It has, likewise, its cadences, though they be freer and in some ways subtler than those of formal verse. Prose may indeed in essence be sometimes simply a less constricted kind of poetry. There are writers like Pater whom one reads for

his phrases; De Quincey, for his images and rhythms; Ruskin, for his purple patches. But they are, to many tastes, simply because they are ambiguous art, not the finest kind of prose writing.

Prose because of its variety and flexibility, the range of things which it can do, becomes the vehicle of an art in which the element of mere style is subsidiary. In a longer essay one would have to pause to consider the essay as that form in which ideas or moods receive a curiously personal, almost lyrical expression, less eloquent than poetry, perhaps, but like a lyric it is a unique expression of an insight or an intuition in which the manner of saying makes half the meaning of what is said.

But as an instance of general aesthetic principles the novel offers a peculiarly interesting and central instance. For fiction is one of the clearest instances of pure creation and throws considerable illumination on what the whole imaginative process is. All experience, from the simplest apperception of an object, is a kind of fiction. We do not see things; we construct them from the random stimulations of impulse and habit. In more than a merely metaphorical sense, chairs and tables, trees and buildings, cabbages and kings, are the busywork of our imagination. The flux of experience provides the data

from which we construct the stable objects around us. Our conception, indeed, of a world is itself a highly architectural fiction. Still more obviously, though not more emphatically, is our knowledge of other people, even our most intimate friends, a fiction we spin, a loose-joined novel we create from the fragmentary data of our contacts with them, from the scattered rumors and gossip out of which we come to make the more or less stable fiction we call an acquaintance or a friend.

All our knowledge is a fictitious picture or an unwritten fiction. The novelist more deliberately marshals details into a background, events into a sequential history, actions and feelings and opinions into a character. The novelist creates a world as surely as, more surely, perhaps, than God created one. Tom Jones, David Copperfield, Anna Karenina have being, clearer and more incontestable, than those half-realized persons, the people next door. More than that. Not only do these characters exist in their own worlds, but their own worlds exist. That Russian society in which Anna led her dazzling and tragic life is gone forever with the changes and chances of war and revolution. But its logic, its folkways, its goods and evils, are there forever. Tolstoy not only represented but in his work created a civilization.

The great and simple appeal of fiction is that it enables us to share imaginatively in the fortunes of these created beings without paying the price in time or defeat for their triumphs and frustrations. One moves with them in lands where one has never been, experiences loves one has never known. And this entrance into lives wider and more various than our own in turn enables us more nicely to appreciate and more intensely to live the lives we do know. It is impossible to say how much novelists teach us to look at our fellow beings, at "their tragic divining of life upon their ways." The novelist is, in one sense, your true philosopher. For any marshaling of people into a story implies a conception of fate, and a philosophy of nature. The least obviously philosophical of novelists, in the choice he makes of events, in the construction he makes of circumstances, indicates and implies what the world, his world, is like. Where a novelist, like some of those in our own day, Hardy and Anatole France and Thomas Mann, are philosophers, they are so in a more rich and living sense than the philosophers of the academy. They imply themselves or express through their characters a total appraisal of existence. They document their estimates with the whole panorama of human experience. They not only judge

but create a world. It is difficult to find in current philosophy a universe more complete and comprehensive than that of a novelist whose mind has ranged over eternity and whose eyes and imagination have traveled widely in time.

# FOUR

## THE THING, THE EYE,
## AND THE PLASTIC ARTS

THE world is there not only to be talked about but to be observed. We have not only tongues with which to speak, and ears with which to hear, but eyes with which to see. Our ears give us, as we have seen, not simply music, sounds void of meaning and sufficient in themselves for our delight. They give us also sounds as symbols, as elements of logical signification. For the eye, too, things may be indifferent symbols as are the letters on a page, or as the particular language in a practical communication or scientific treatise happens to be written. The things about us to the completely pragmatic or hurried intelligence constitute merely a succession of symbols. As Roger Fry points out in *Vision and Design,* in the ordinary seeing we do during the day,

86

we do not in any aesthetic sense use our eyes at all. We see as much of objects, so to put it, as we need to get around with. What is there plastically, in the way of color and line and shape and volume, we do not see at all.

But colors and shapes are more or less arresting to everyone. All of us, the psychologists tell us, respond to sensory stimuli with a motor response. In most people, however, the response is merely incipient. It is merely the twitch of a muscle or the hardly noticed excitation of a sensory nerve. The painter and sculptor, however, turn their sensations into deliberate motor responses and incarnate those responses on canvas or in marble. The observer, too, regarding a work of plastic art, is arrested by its specifically plastic values, by what is there actually to the eye.

That there are in the plastic arts other values than merely plastic ones we shall have occasion presently to observe. The eye is always the eye of a human being, and what is visually present may, like the words of prose or poetry, stir imagination. The shape and color are the shape and color of something, and this pyramid on canvas is a Holy Family, that ellipse is a face, that splash of red is a cloak or the radiant part of a sunset. The things represented in a painting are associated with the whole

repertory of human passions. The eye observing is that of a human being whose eyes are connected with other than purely visual apparatus, and who has other than purely aesthetic interests. So much is this the case that there are persons with whom painting is always a vivid and visible poetry, who never have been trained and who never discipline themselves to the enjoyment of what is simply and clearly there to the eye. The purely plastic enjoyment of a picture would be restricted to the lines and colors on canvas, the forms and masses of sculpture, the surfaces and volumes of architecture. In the case of architecture, as we shall presently see, considerations of utility enter into the aesthetic enjoyment itself. But the utility is incarnate in the building; it is *seen* as utility rather than imagined or thought to be such.

The first step toward plastic appreciation is to recover the immediacy and innocence of the eye, and to live for the moment of observation in what is visually there. For many, painting is merely a photography in color, etching a photography in which the lines are clear and fine. But the lover of painting and etching as such is not interested primarily in representation at all. He is interested in what he can see and what he can enjoy *seeing*.

In painting this consists primarily in color, line, and mass. In one sense it is hopeless and futile to discuss painting at all in words. As well might one try to render the experience of a Bach fugue in a logical formula. The specific effect of line, the unique appeal of various combinations of color are precisely what they are and as they are seen. No translation into the medium of words is adequate. The effects of painting are like what the mystic describes as the effects of the vision of God, incommunicable. One can at best indicate by indirection the kind of pleasure that a painting gives us. As De Witt Parker admirably puts it in his *Principles of Aesthetics:*

"It is not sufficient that the picture move us through the vicarious presence on a canvas of a moving object; it must stir us in a more immediate fashion through the direct appeal of sense. For example, a picture which presents us with a semblance of the sea will hold us through the power which the sea has over us; but it will not hold us so fast as a picture of the same subject which in addition grips us through its greens and blues and wavy lines. The one sways only through the imagination; the other through our senses as well." Colors like tones are the functions of vibrations, and differences in the vibration of the ether produce differences in color. These different

colors have specific qualities and specific nervous effects, as induplicable and untranslatable into other terms as specific sounds or tastes or smells. Quite apart, then, from any differences in association color differences themselves have specific effects of pleasure or minor pain. There are discords in color as in sound; there are colors brilliant and intense like purple or violet, or soft and reti- :ent like the quieter shades of blue. The color organ, at- tempted some years ago, tried to make, not without success, an abstract art of color similar to the abstract art of tones which is music. Some persons more than others are extremely sensitive to these subtle variations in colors. The whole mood and magic of a painting may be conditioned by an artist's gift in exploiting these pri- mary nervous excitations which different color combina- tions make.

But in our ordinary experience, colors are not simply what they are to the eye; they are associated with sensa- tions or memories pleasant or unpleasant: red with blood, blue with the sky, yellow with sunlight and summer, black with mourning, and gray with autumn or with gloom. In some unexplained way, so interrelated are our sensations and our memories, the colors in a painting may have intensified effects through these hardly realized

associations. What colors are to the eye and what they evoke in the memory are both essential features of their aesthetic effect.

One may come indeed to love color in and for itself, as in a chameleon or a kaleidoscope or the sky or the sand or the sea. One may lose one's self in it as in a timeless kind of music. In stained glass, in some tapestries, in precious stones, color may indeed be the whole of one's absorption. But in painting color is seldom experienced or enjoyed in isolation. It appears as a spot in a composition; it is bounded by lines; it accentuates shapes. Even in Venetian painting, Titian and Tintoretto, for example, where color is the central and most notable glory, the color is the color of something, and there is structure as well as vibration in the painting. "A painting is not a design in spots, meant merely to outdo a sunset; it is a richer dream of experience meant to outshine the reality."

The effect of color is to create a kind of plastic harmony and to induce a visual atmosphere. The objects in a painting become subdued to a certain light and hue; they become elements in an optical atmosphere. From one point of view, color is indeed an obbligato in painting. For objects are represented by lines and a painting is constructed of them. Color glorifies the act of vision, giving

it intensity and vitality and depths. But the eye, when it sees, makes an act of synthesis, and synthesis is made possible through the forms and shapes which lines make possible.

Lines, too, like colors, have specific effects. We speak vernacularly of beautiful things as being "easy to look at." The symmetrical balance of parts of a painting, the easy fluency of a curved line, the decision of a straight one, all are contributions to our aesthetic pleasure. Specific types of lines, jagged and broken ones, smooth or wavy ones, circles and ellipses, all, like the high and low notes of music, the intense and dull tinges and values of color, have unique nervous correlations. The lines in painting, like the rhythms in music, are themselves a kind of music. That this is so can easily be demonstrated by an experiment with such works of art as etchings, where there is no effect of color, or some painting, notably the Florentine, where these are often poor or secondary. To see a line is, for those sensitive to visual appeal, to move incipiently with it, and to live in the abstract object of their rhythmic combinations. Thus apart from any other element of aesthetic contrivance, the vertical reaches of Gothic art, the predominant horizontal of Renaissance construction, the dancing lines of a Greek vase, or the

skeletal stiffness of archaic painting, all are immediate and intrinsic elements of aesthetic pleasure.

There is good reason to believe that the effect of line *qua* line in painting is at once a vicarious sense of touch and a vicarious sense of motion. "Empathy" is the term some aestheticians like to use to describe the source of pleasure of the observer in the lines of painting and sculpture. By "empathy" or *Einfuehlung* is meant that tendency of the body to experience in its own tensions and incipient movements what it perceives in external objects. We move in imagination and almost in fact with the lines of the paintings; a broken rhythm on the canvas breaks the flow of our perception and our impulsive motor response. A fluent and wavy line releases tension and makes both our perception and our half-realized reaction easy and pleasurable. Just as in literature we live in the pages of a novel the lives of the imagined characters, so in painting we may be said to live the life of the lines on the canvas or in marble. The effect of empathy is most notable and obvious in sculpture. We feel ourselves poised in movement and in rest with the discus thrower, and our own muscles grow tight with the tensions of some of the figures, tortured and muscular, of Michelangelo.

# ARTS AND THE MAN

Walter Pater once suggested that each art, when successful, exploited its peculiar material and its specific technical resources. The pleasure to be derived from painting derives from the eye, the specific organ to which it is addressed. Critics, especially contemporary critics, therefore, insist, as Mr. Albert C. Barnes does at great and persuasive length in his *The Art in Painting,* on the primary and plastic values in painting. The same holds true, of course, for sculpture. Logically speaking, there is no reason why painting should not, like music, be a completely abstract art, in which the elements of line and color and mass should be all that engaged the attention or all that should be expected to provide the enjoyment of the observer. From this extreme point of view, whether the composition or structure of a painting be a Madonna and a group of saints, or a bowl of fruit, or a group of buildings, is utterly indifferent. The literary or human significance of a painting is, *qua* painting, utterly indifferent. To the critic intent upon studying the pictorial values of painting, a geometric diagram of its structure, a map, as it were, of its colors, would be of immense interest, quite independent of what the objects represented were. Indeed, there are certain extremists in contemporary criticism of painting who forecast art in

which there would be no representation of objects whatso-
ever, in which the attention would have to be confined to
what was immediately there to the eye because there
would be nothing represented to distract the attention
and the imagination.

That the observer's eye and the painter's attention
should be concentrated upon purely plastic values goes
without saying. Otherwise the art of painting becomes
a sentimental form of visual poetry. The eye is not on
the outer object but on an adventitious inner reverie. The
enjoyment of painting becomes the literature of those
who do not know how to read. But that painting will
ever become an art of purely abstract color and form is
extremely dubious. There are indeed good and purely
aesthetic reasons why it should not. Objects of human
interest and concern and familiarity have the aesthetic
merit of fixing the attention. A painting does not lose
quality because its subject is a humanly interesting face,
or a landscape in which one might find peace or freedom
or joy. All that the painter and observer need remember
is that it is not the subject that makes the painting, nor
must the painter rely upon the human interest of his
subject as a substitute for aesthetic pleasure. The objects
represented must achieve in the painting pictorial value.

What is humanly interesting must become in the immediacy of color and line plastically delightful. The naïve observer who complains, therefore, that he never saw a face or a sunset that "looked like that" is telling the truth. But the truth that he tells is not an aesthetic condemnation of the painting. The artist is not trying to represent Nature as a photograph might represent it. He is trying rather through the resources of his art to convert some aspect of Nature or of the human world into a composition interesting for what meets the eye and expressive rather of his total imaginative reaction to what he has seen than to that which in any neutral and objective sense is there. A brilliance of color impossible in Nature may be aesthetically justified; a composition of lines that no landscape ever contained may make that landscape aesthetically real, if not literally true. A distortion of Nature may be necessary in the proportions of a painting.

The painter does not try in any slavish sense to imitate Nature, nor is he a logician trying to give a copy of reality. What is important is the *aesthetic* reality, that is, the sensuous vividness and plastic pleasure of a given moment of vision of an artist as he has embodied it in stone or on canvas. That reality is attained through color or line. The justification of any combinations a

painter may make of those is in the intensity and vivid-
ness and specifically pictorial beauty these produce. Thus
the best portrait of a man may not in any literal sense
be the truest. There may be colors in his face that the
artist found but that Nature had not put there; and the
line of his jaw might be such as no photograph would
exactly show. But the portrait might none the less render
that man magnificently vivid to his friends—or to those
who had never known him. The distortion from Nature
might be part of the technique an artist uses to make it
an arresting picture and a good one, good not in any
sense of verisimilitude or likeness, but "good to look at"
and aesthetically real.

The objects in a painting may indeed be said to be
much less copies of a real world than elements of a reality
that is nothing but the painting itself. The unity of that
painted cosmos is the light in which the painter bathes
all the objects inhabiting that particular framed segment
of space. The structure of that world is in terms of that
harmonious balance and integration of colors, lines, and
masses which the painter has proposed to himself and
effected. That little colored world becomes estimable
not by the degree to which it "represents" a part of the
world outside it, but by the extent to which it is clear,

luminous, and organized in its own plastic terms of color and line and purely pictorial mood. In a picture by Giorgione or almost any of the Venetians, it is the common pervasive light in which the objects seem to breathe that gives the painting tonal unity. In the Florentines, in many contemporaries, it is the structure, almost geometrically separable from the painting, that constitutes the essence of its pictorial being. The pleasure to be derived from it is the pleasure of form, "a synthesis of the seen."

That painting is a kind of poetry or has its own kind of poetry goes without saying. But the poetry of the plastic arts is not to be confused with the poetry of words. What is poetic in painting is not any literary subject matter. It is not the pastoral courtiers of Watteau that make his paintings an enameled pictorial verse. But those courtiers have been translated or rather objectified in the hued and linear moods of painting. The poetry of painting is line and color, which have their own imaginative reverberations, induce a hypnosis and a dream in a way that is analogous to that of words and rhythms but that is none the less distinctly that of painting, not of poetry. Those liquid blues or yellows or reds or browns, that shadow falling here, that dash of line here, that emphasis of mass there, it is in terms of these that the eye lives

for the moment and in terms of these, too, that the plastically moved imagination is controlled. Rembrandt's tragic figures and El Greco's grandees, the young aristocrats pictured by the Florentine Bronzino, may move us to reverie, but if we are actually looking at the picture, the reverie, too, will be pictorial, and it will be a meditation in terms of what is there to be seen.

The general considerations applicable to painting apply to sculpture also, and such special technical considerations as concern that art, this is not the place to consider. But there are one or two aspects of sculpture which make it more than technically a distinctive art. Its theme and subject matter, in the first place, is primarily the human body, itself to human beings the most interesting of human objects and ideally the most beautiful. Sculpture may, therefore, have a twin appeal, the plastic appeal of its sensuous charm, and the translation into plastic and visual terms of those moral attitudes and logical intentions and imaginative associations of the familiar and beloved human type. The sculptured figure is interesting to look at, arouses feelings of muscular sympathy and tension and repose, awakens incipiently the desire to touch and the sense of touch. But it is also a human figure arresting by its associations of heroic dignity or

moral grandeur, or youthful grace or strength, like the heroes or the gods or the athletes of the Greeks. In sculpture the mind of man becomes visibly incarnate, as does his will and his desire. The figure carved out of a block of marble is more than a figure in marble; it is some selective ideal of humanity, eternalized in stone.

For this and for other reasons, sculpture demands a kind of grandeur of theme, and has flourished in ages where life was in the grand manner and afforded, as did Athens, or Italy in the Renaissance, grand themes for the sculptor. But sculpture, even apart from the fact that it is the plastic embodiment of the human figure and all the imaginative possibilities of expression that the human figure suggests, has other problems than those of (and in addition to those of) painting. A painting is seen from one aspect; a statue is theoretically seeable from infinite points of view. The statue from any angle must make an interesting composition. Sculpture has not, save in exceptional instances, the resource of color. It depends on line and on mass for its effect. Sculpture awakens specifically the impulse to touch; the quality of the sculptured surface, bronze or marble, rough or smooth, is of immense aesthetic importance. Sculpture, dealing as it does almost exclusively with the nude, must in our own

civilization seem always a somewhat stilted and somewhat anachronistic art. Where it deals with the individualized instance, it harks back to Renaissance genres; where it deals with the generic and universalized type, it suggests the Greek. It is a beautiful art, but a chill, retrospective monument to a civilization that is dead. That a new sculpture may arise, however, expressive of the vision and of our contemporaries and of the objects which they see, some of the newer "abstract" sculpture is beginning to suggest.

For an illustration, however, of the general principles involved in aesthetic creation and appreciation, there could not, perhaps, be a better choice than the art of architecture. At its freest and most inspired triumphs, it has all the color and line of painting, the decorative and monumental character of sculpture, the imaginative suggestiveness and suasion of poetry. A Gothic cathedral, a Greek temple, a contemporary college tower or industrial plant or bridge, may combine all the seductions of all the arts, save that of music (and Schlegel said architecture was frozen music), and have a spatial reality and impressiveness to which the others cannot lay claim. At the same time architecture, unlike the other arts, never quite forgets or allows the architect or the builder to

forget that a building has a use as well as an appearance, that it is not simply a decoration on the landscape, but a structure used by a person or a community for special functions that have determined among other things its appearance.

Architecture, then, is that art ambiguous and crucial that lies on the border line between beauty and use. It is so much a part of our daily environment that we forget often that it is an art, as M. Jourdain forgot in Molière's play that he had been speaking prose all his life. We are surrounded by buildings, beautiful or ugly; we live in them; we accept them. If any art conditions our aesthetic response, it is that of architecture. Paintings can be hidden in museums; poems may be unread and music unheard, but buildings, especially monumental ones, must be seen by those whom business or the routine of life obliges to pass them. "Doctors," someone remarked, "bury their mistakes; architects build theirs."

There is another sense, too, in which architecture is conditioned, not to add limited; it is expensive and the products of architectural imagination are laborious in the execution. The poet, the musician, and the painter all require infinitely less in the way of materials and men.

The fact that architecture is what we have called an

ambiguous art, however, is not a qualification so much as an intensification of its beauty. The fact that a building has to appeal to the imagination with respect to its fitness for its function simply gives an additional dimension to architectural beauty. A building appeals not simply by its size, form, and color, but by its appositeness to its human and social intention. A château on the Loire, a mosque at Constantinople, a railway terminal in New York, gain a deepened beauty through the incarnation, express and visible, of the life lived or served in them.

But a building remains, first and foremost, none the less, a sight for the eye. Seen from any angle it is a surface, like a painting, and like a painting must be interesting and satisfying in terms of color and form, but in architecture, save in the rare and melodramatic instances of such polychrome façades as one finds in certain Renaissance Italian churches, it is form that is essential. Any façade of a building must be seen as a unit, but its unity must be varied enough to retain and absorb the attention. The building must be clear in structure, like a Greek temple or a Gothic interior, but the structure must be enhanced and diversified as the columns of a Greek temple are by capitals, as the façade of a Gothic church is by decorative sculpture. The beauty of architecture and

the focus of aesthetic attention which it provokes oscillate indeed between ornament and structure, though for architecture, whose effect is monumental and large scale, structure must always be predominant. A building is imposing by virtue of its grand and central lines and masses. Only an attention more fastidious and explicit will note with admiring care the details of decoration which the architectural plan makes possible and which vivify and diversify the architectural plan. Thus, a careful scrutiny of the cathedral at Chartres may lead the observer to be fascinated by the details of the sculpture in the portals or the figures in the stained glass. But the sculptures are, after all, details in the structural scheme of the façade; the colors of the stained glass in the rose window serve, from the architect's point of view, simply to enhance and glorify the mood and depths which the vaulted interior reveal. An architect's attitude toward ornament is like the disciplined poet's attitude toward euphonious and colorful words. He will employ them to intensify his effects; he will not allow his effects to be destroyed by them.

If decoration is conditioned by the structure which it adorns and italicizes, structure in its turn is conditioned by function. Part of the beauty of a building is the sense

it gives of its adaptation to its function, the nice adaptation of what is seen to the object it is intended to serve. Thus the great monuments of European architecture express with a certain fidelity and in the obviousness of plastic materials what the building is designed to do or be. It is a visible token to the architect's intention. The Palazzo del Té at Mantua is in its whole conception and appearance a palace of pleasure, and the cathedral at Amiens, besides being structurally clear and beautiful, is unimpeachably and unmistakably a religious edifice.

Nor must a building simply express its function; it must, likewise, if it is honest architecture, express its materials. Some of the most outstanding instances of contemporary architecture are those in which the architect has obviously taken cognizance that he is working in steel and in glass rather than in stone and wood. We are beginning to pass from the stage where a bank built on a steel framework imitates a Greek temple or a Renaissance palace built mosaically of stone. There is something irritating aesthetically in a building that fools at once the eye and the imagination.

In a broad sense, a sound architecture, one plastically beautiful and imaginatively and structurally honest, is one of the best and clearest indices of the state of a civiliza-

tion. The French not inaptly or unjustly refer to the
châteaux, palaces, and churches with which their land
is dotted as *monuments historiques*. They are indeed
historical monuments. For in a building more than in
any other work the social imagination has expressed it-
self. How a nation builds, the structures on which it
spends its elaborate energies, the character of its favorite
architectural motifs, tell us more about a people, almost,
than its prose or its poetry or music, since these have a
greater license to be irrelevant or trivial or fantastic. A
church, a university, a prison, a dwelling house, a bank, a
theater, or a town hall, all these are centers of social life
and expressive of it. A Greek temple shining on a hill, a
Gothic cathedral in the center of a cluster of gabled
houses, a Renaissance palace, a modern skyscraper, all
steel and glass and vertical line, tell us more about a
civilization than almost any other work of art. For it is
in and among buildings that we live and move and have
our being, and by their decorative beauty, their structural
unity, their imaginative fitness, or the lack of these, the
quality of our lives is revealed and indeed determined.

# FIVE

## SOUNDS, THE EARS, AND THE MUSICIAN

I N the chapter on language, it was pointed out that sound moves in two directions and has two possible alternatives. It may be a mere "pattering on the ear," delightful in itself, but from the point of view of explicit significance quite negligible, or it may become a vehicle of ideas, a system of signals or symbols whose sensuous quality is utterly negligible, in which the sound is forgotten completely in the sense. One might, for example, go for a day paying exclusive attention to the quality of voices and the syllables they uttered, or in a foreign country where one did not know the language one might be absorbed completely by the melody of what was being said. Sound become a vehicle of significance is language, which is turned in poetry or prose into an

art. But the purely aural qualities of it may be exploited and that exploitation is music, signifying, in a logical sense, nothing, but aesthetically of the first, and often emotionally of the most poignant importance.

Music, too, illustrates the principle of all the arts, that of being sensuous in its basis and ranging in its possibility of appeal to the most abstract and intellectual of effects and appeals. The appeal of music has, like that of the other arts, an explicit and obvious physical basis. The pitch of a note is determined by the rate of vibration of the air, its color is determined by the presence of overtones, its intensity is dependent upon the amplitude of vibration, its quality by its relative position in the scale.

The tones at the disposal of Western musicians are, of course, arbitrary, and some of the newer music is indicating how arbitrary the selection is. But out of these tones an infinite variety of combinations is possible. The tones of music, like the separate sounds of syllables, may be pleasant. But even more than the sound in words, the character of musical effect depends on their succession. Music is above all a temporal art, and its effect is that of a succession of tones, each of which qualifies the aesthetic effect of the succeeding. It has been pointed out in a dif-

ferent connection how much of our sensations are memo-
ries rather than sensations, and in music the feeling tone
of any note is immensely affected by the tonal sequence
in which it appears. Tones themselves, like colors, are
pleasant or unpleasant, and are, without reference to their
associations, sharp or stinging or sweet or soft or loud
and there are specific nervous correlations to each kind
and indeed to each nuance of tone. Tones, moreover, like
any other sensations, evoke memories and associations.
Some tones like those of a trumpet are warlike; others
like those of violins and flutes are sylvan and tender. But
the separate tonal effects of tones are incidental to their
functions in that rhythmic-melodic process which is a
musical composition. A melody is a chord taken piece-
meal and suspended through time. A note sets a given
musical expectation which the melodic development ful-
fills. The whole elaborate construction of the most in-
tricate musical composition is simply a complication of
the melodic deployment of notes in a scale and tones
with harmonic relations to each other. However com-
plicated music becomes, it is, *au fond,* simply notes in a
melody and notes in a chord. But the notes have not
simply a melodic relation to each other in a succession of
moments and a harmonic relation to others at an instant

in harmony. Notes occur in a rhythm, and, as in poetry, the rhythm of music is its fundamental hypnosis, and for the same reasons. Rhythm enables us to hear music with economical comprehension; the tones fall into easily apprehensible units. But the beat of music has a more imperious utility than that it permits apprehension. Our own bodily machinery has a rhythmical character; we are creatures whose fundamental processes of living are rhythmic, and creatures, too, whose rhythms are subtly affected by those rhythms external to us that come to us through the ear. Our whole emotional life has a rhythmic character and quality. Our very thoughts come to us in an ebb and flow.

To rhythms in music the rhythms in our consciousness are extraordinarily responsive. A change in beat is for the moment a change in our own being. In Eugene O'Neill's *Emperor Jones,* the beating of the tom-tom becomes the obsessional domination of the Negro hero. The subtler beats and variations of symphonic music affect the consciousness of more circumspect and civilized listeners. In the languorous luxury of the love motifs in Wagner, the rhythmic beat of the dances in *Prince Igor,* quite apart from subtler effects, the mere animal control enforced by the rhythmic basis of the music is

responsible for the musical effect. There is something imperious about the sound of music that is lacking to any other art. We either do not listen to music or in listening to it become for the time being one with its time and rhythm, confluent with its own rhythmic process.

But while rhythm is the basis and in a certain sense the substance, it is not the whole of music. It is the generic condition of all music but it is not the specific being of any. The latter may be said to lie rather in the melodic line, along which the attention moves, only more poignantly and intimately than the attention moves with the lines of a painting. When one is absorbed by music, one lives for the time being along the progression of that rise and fall, deviation and resolution of tones which constitute a melody. The life of the melody, that abstract and spaceless theme singing through time, is the life of the listener. Our own will, in Schopenhauer's luminous mythology, is objectified in the surge and complication of the music.

The pleasures of music flow from this triple fact of tone, rhythm, and melody. The enjoyment of all three may be purely sensuous in character. One may merely luxuriate vaguely or with precision in the abstract and objectless world of sounds, discriminating separate tones

in their liquid loveliness of violin or flute, or their reso-
nance of brass; one may loiter along with the melody
in the devious wanderings from the tonic note and in its
return. One may glory in the purely physical excitement
of a whole orchestral outburst of harmony or a kaleido-
scopic cascade of sound. However complex the sensations
of music may be—and there is no limit almost to which
musical sensibility and the resources of orchestration are
bound—the enjoyment may be purely sensational, an
elaborate patter upon the ear, but none the less a patter.

To the more disciplined musical intelligence, music
may come to be more than a pyrotechnic attack upon
the eardrum, a splendid fireworks of sound. There is
perhaps no other art where the pleasures of mere form
are more marvelous in complexity, more intellectual in
essence, in quality more pure. The complication of mu-
sical structure is indeed expressible only in music itself,
for neither language nor life permits such involution and
internal reticulation as is possible in those edifices, tran-
siently existent in time, that we call musical composi-
tions. These structures are intellectual in essence; they
are musical essences or ideas internally related to each
other; a Bach fugue is a dialectic become transitive and
audible; the deployment of a theme in contrapuntal vari-

ations is an operation of mathematical ingenuity that few logicians could equal in words. A musical score is, without being played, of compelling absorption to the trained musician; it is a realm of Platonic ideas dialectically related to each other. It was something of this sort that Schopenhauer had in mind when he said that an adequate symphony would be a complete metaphysical transcript of existence. The world of musical form is thoroughly abstract; it exists nowhere save in itself, but its complications and its clarities transcend those that any other realm of being reveals. What we call the external world is largely a systematic inference from data received through the eye. The world heard in music is a construction inferred from the ear. One could imagine eyeless creatures to whom a world of sound was the only reality. And to the human temporarily absorbed in listening, who shall say that a Brahms symphony or one by Mozart is not, for the time being, a completely real world, far more perspicacious and congenial than the realm, strident and confused, in which our practical logic and imagination are compelled to live.

Nor is there any art where the pleasures of form are so pure. Music exists truly nowhere save as heard or as imagined in audible terms. It is always nine-tenths

memory or premonition, since what is given at any instant is only one tone or one harmonious complication of tones. Music is bodiless and lives only as rhythmic life heard through a brief sequence of moments in time. Its instruments are material, since the most unearthly of music must be played on wood, on brass, and on string. Its appeal is through the physiological apparatus of the ear. But to the experienced listener, the sensuous quality of musical sounds is the incidental feature, though the delightful one, of those pure and subtle relations which are the genius of musical invention. Philosophers and poets seeking an image for the total operations of things have thought to detect a music of the spheres. A great and comprehensive symphony is a universe in itself, and the listener's imagination is freed from the logic of things and affairs, to live for a time in that pure and abstract mathematics of sound.

One of the curiosities of music is that this objectless realm of sounds, irrelevant to anything but its own internal relations, should have so compelling an emotional effect on the listener. For this art cannot be treated merely as sensuous titillation or as a mathematical pleasure. Its universal appeal, the poignancy of its effect on even the most intellectual of listeners or the most sensu-

ously susceptible, demand some inquiry. Music is, for all its abstractness and its apparent meaninglessness, profoundly and subtly related to emotion. How is it that sounds signifying nothing should come at moments to mean, as it were, everything, or many things to many listeners? How it is that an art which is no language at all should come to be described, even metaphorically, as a universal language?

The hypnosis of music has already been attributed to the fundamental fact of rhythm, to which we respond not merely with the ear but with the whole movement of our bodies and the dominant tempo of our imaginations. If we pay attention to music at all, we are rushed along on its current and become, in no trivial sense, part of its current ourselves.

But it is not rhythm alone which can explain the emotional effects of music. Part of the intimate and moving appeal of music is, as De Witt Parker suggests, to be attributed to the fact that music retains, even in its complex forms, a quality lyric and personal, an echo or an approximation of the human voice. The violin sings and all music is thinkable as a kind of complicated singing. All that direct and unmistakable personal address which is native to the human voice is indigenous, too, to most

music. There are sounds, too, in music that recall characteristic moods and crises in our nonmusical experience. It may be thunderous or plaintive, frightening or soothing, like analogous sounds of those moods in ordinary life. There is indeed a cheap kind of musical exploitation of effects of Nature in music, an instrumental onomatopoeia, in which the crash of thunder, the singing of birds, the ripple of water, the bleating of sheep may be imitated. But it is not by such imitation that the subtlest emotional effects of music are contrived. Rather the movement of a melody, though it says nothing specific, in some unspecified way awakens a whole reverberation of nervous response. In real life, our emotional responses tend to go over into action, or to become absorbed by some object. In music, the sounds that provoke some reverberant response are the only objects upon which that response can be made. The very music that rouses us appeases us; in the sounds that give us stimulation we find our peace.

There is, of course, a sense in which music is utterly inadequate to express emotion at all. Tones are tones, melodies are tonal relations in time; harmonies are tonal relations at an instant. They can, none of them, say what language can say specifically or what some situation in life can specifically exemplify. But just because music

cannot be specific it can render with voluminousness and depths the general atmosphere or aura of emotion. It can suggest love, though no love in particular; worship or despair, though it does not say who is worshiped or what is the cause of the despair. Into the same music, therefore, a hundred different listeners will pour their own specific histories and desires. A thousand different sorrows and a thousand different joys will be called to focus by the same musical material. And the very fact that there is nothing definitive or exclusive in the emotional atmosphere of a given composition will make it all the more accessible as a means of catharsis or relief for the listener. Words are too brittle and chiseled, life too rigid and conventional to exhaust all the infinity of human emotional response. The infinite sinuousness, nuance, and complexity of music enable it to speak in a thousand different accents to a thousand different listeners, and to say with noncommittal and moving intimacy what no language would acknowledge or express and what no situations in life could completely exhaust or make possible.

This art of sound, then, at first hearing so completely spontaneous, at closer examination so disciplined and mathematical, at once stingingly sensuous and austerely

intellectual, has more consequence on life and society than might be imagined. In its twin freedom and control, it is an anagram of what a civilized society might be. In its intellectual structure and clarity it offers an audition of such rationality as no society has as yet exemplified. In its unspoken but deeply uttered refinement of emotion, it makes the passions and crises of this world seem awkward and gross. Plato imagined philosophy as a finer kind of music. And he suggested what is apparently (but only apparently) fantastic: that a refined musical sensibility might be the most civilizing of educational instruments. For a mind educated to musical form and an imagination refined to the finesse of musical emotion cannot remain completely gross in the contacts of life. Moral and musical taste may not be altogether unrelated. For a rational civilization would in its sensuous beauty, its emotional delicacy, and its intellectual order be very like the noblest and the best in music.

# SIX

## ART AND PHILOSOPHY

NOT even the briefest consideration of the philosophy of art can fail to be concerned with the relation of art and philosophy itself. Superficially, no two people would seem to be further apart than the artist and the philosopher. The concern of the first is with the sensuous excitements of materials, the pleasures of evident form, the persuasions of emotional resonance. The second is preoccupied, by intention at least, with the passionless consideration of logically related themes, with general and therefore abstract ideas. The artist is concerned with the face of beauty; the philosopher with the anatomy of truth. Their vocabularies and their techniques, as well as their ambitions, differ. The poet and the philosopher at least have this in common: they both use words. But the one uses the evocative epithet to convey a concrete image, the other

the term, often of necessity colorless and dull, to convey a universal or to fix an implication. The artist, too, has his logic, but it is that of the organization of materials or the congruity of mood. It is not the dialectic, abstract and internal, of the thinker.

There is, too, or there appears superficially to be, a moral enmity between the arts and philosophy. For all of Keats the suasion of beauty is often a seduction from the conviction of truth, and there is an *askesis*, an intellectual discipline, in philosophy that is absent from all but the most austere art. The artist, on the other hand, is properly suspicious of formulas demanding intellectual comprehension. His business is the creation of fresh and immediately sensible forms. The thinker is, not without warrant, disdainful of, when not downright impatient with, the insistence upon the sensuous surface, the emotional incidence of ideas. His mind, too, is intent upon structure, but it is, so far as lies within his competence and conscience, the structure of truth. The poet and the painter insist on keeping their eyes on the object; so does the philosopher, but his ultimate object is seamless and eternal being, or the exact definition of the lines and intersections of his own thinking.

But despite the differences and the enmities between the two enterprises, art and philosophy both resemble and involve each other. The artist when he ceases to be merely a gifted and trifling craftsman turns out to be, in his very choice of themes, in his selection of materials, in his total and residual effect, a commentator on life and existence; in his immediate and imaginative way he is a philosopher. The philosopher, constructing through the apparatus of definition and demonstration, or of discovery and synthesis, a complete vision of life and existence, is making a canvas of the whole of experience, composing an intellectual symphony, and fabricating a poem, however much his language be prose. "Philosophy," Socrates is made to say by Plato, "is a finer kind of music," and like serious music, however unmoved the mind that went to its making, it is moving.

Again, apart from the resemblances between the two enterprises, the philosopher cannot honestly or, if he is to be comprehensive, decently ignore the arts or the artist. The very rationality which the philosopher seeks to find or make possible in the universe the artist in his small area and within the scope of his materials is trying to achieve. The organization of each created little world is

a *simulacrum,* a cameo version of the order which philosophers have tried, with such pathetic insistence, to find in or read into the universe. The arts have attracted the professional attention of philosophers from the fact that the order they would demonstrate is perhaps exemplified or achieved only in the organization of a masterpiece where all the parts interpenetrate and constitute living rationality such as the universe may, but only possibly may, be. But the arts call for the attention of philosophers and have received it for another reason. They posit issues of morals and knowledge and truth that no philosopher worthy of the designation can ignore.

It is, as we have seen, on the moral side that philosophers have troubled, one might almost say have *been* troubled, to consider the arts. One may try to exclude the emotions and discount the senses in the construction of a cosmology or the definition of a method. But the life of the senses and the influences of the emotions demand analysis and provoke consideration. They must be reckoned with in any moral program and must be defined and given their proper due in any moral method. For better or for worse the arts patently play a large part in the affairs, and are not without consequence for the passions, of mankind. They must of necessity, therefore,

enter into the speculations of philosophers. And they have done so.

The arts have been reviled or grudgingly acknowledged, even regarded, as in Plato, as the sources and instruments of moral discipline. The reasons for the reviling we have already seen. Whenever a philosopher sets up the Spirit as over against the Flesh and spirituality as over against carnality he will naturally be suspicious, as are nearly all Christian moralists, of the fine arts. These amusements, so delicious to those initiate to them, are the preoccupations of Nineveh and Tyre; they are the more exigent public interests, not quite disguising the private ones, of Sodom and Gomorrah. The artist is a dangerous, because he is a distracting and disintegrating, person. So speak most Christian and all ascetic moral philosophers. So speaks Plato when he is being the rational statesman rather than the enchanted and enchanting poet. The Freudian exploration has but served to confirm the moral suspicions of traditional ascetics. The sexual resonance in the fine arts, the indirect, half-hushed, sensuous response, the play of sex in the forms and materials, the easy transition from emotions specifically sexual to muted and transmuted aesthetic ardors —these insights of the psychiatrists confirm the nervous

apprehensions of the Puritans. Whatever conclusions be drawn from these facts, about the facts themselves the modern psychoanalyst and the ancient Puritan agree.

But the quarrel is something more, and something different from that between flesh and spirit. Why, at the close of the *Republic*, does Socrates, who had previously merely censored, now exclude, albeit reluctantly, the artist from the Perfect State? Plato does not so much think the artist incites flesh as that he diverts and distracts the mind, keeps the attention exquisitely enamored by the sensuous *simulacra* of things, which are, for their part, the imperfect shadows of ideas. There has long been in the history of thought a casuistry as to the part that "the sense and ideas play in the building of the house of thought." But from the point of view of that strict intellectualism recurrent in the history of philosophy, the devotees of the arts and the practitioners of them, being controlled by or busy with materials and things, are fundamentally suspect. Indeed, whenever the arts have been defended by rationalists, as in Plato's *Symposium*, the argument has been that the materials are incidental, and the senses but the first step in initiation to those changeless forms or types or essences

which beautiful physical things half incarnate and half disguise or traduce.

The philosopher's consideration of the fine arts may have its origin in the quarrel between the claims of flesh and spirit, or sense and mind. But without the provocation of any such source of conflict, there is an additional reason why the philosopher cannot ignore, though he may wish to do so, and must admit to some interest in, the fine arts, however ignorant of them he may be. Most philosophies that pretend to be anything but a purely formal logic or a purely detached metaphysics, or even those that do not pretend to be any more, issue in a moral philosophy. Now a moral philosophy, whatever its origins be or whatever the ends toward which it moves or the sanctions toward which it turns, is primarily an examination of the good life. That good life is a program for a future in this world or the next. It is a regimen for the conduct of living; it is concerned with remediable evils and attainable goods, with happiness in this world or salvation in the next. But with the possible exception of the most outspoken hedonism—the morality of the moment's pleasure—moral philosophies have located the good in some future, if it be only tomorrow, if even that

morrow be regarded as precarious or brief. For most moral philosophies, however Epicurean, have been tinctured with Stoicism: not pleasure but duty has been the end. Not the present but the long future, not the urgency of the actual moment but the obligation of the long past, religious or social, has determined them.

The arts, however, either by example or by implication, have located the goods of life in the present; these goods have been found in the palpable delights of the senses, in the direct deliverances of feeling. Works of art have been conspicuous celebrations of the moment; in however refined and exquisite a way, pleasure has been their justification. So much is this the case that beauty can plausibly be defined by Santayana as "pleasure objectified." In a world where much remains to be done (and undone), where obligations remain to be fulfilled, the arts have come to us "proposing frankly to give nothing but the highest quality to [our] moments as they pass, and for those moments' sake." No wonder the moralist has no use for the very uses of art, regards its delights as distractions, and its pleasures as truancies from duty. "Not the fruit of experience but experience itself is the end," wrote Walter Pater.

Experience without fruit is barren to the earnest la-

borer in the moral vineyard. But a characteristic human enterprise cannot be dismissed by fiat, even that of the philosopher. When reasons are found for abolishing it, it remains and, to human beings engrossed by it, is its own good reason for being. So for better or worse philosophers have had to find a place in their economy for the arts they have exiled or condemned. The senses continue to seduce and the imagination to persuade. Moral philosophers have thus found it the part of reason or discretion to reinstate both, and on moral grounds. St. Augustine, who, along with the flesh, had renounced rhetoric and the beautiful, used the former to defend the latter after his conversion. The senses were an initiation through visible forms to the great invisible beauty of Form and thus to God Himself. St. Bonaventura regarded the universe as the language of God, and saints as the apt poets of God's language.

Above all, since men remained susceptible to the arts, whatever God might command or reason demonstrate, perhaps God or reason could find an instrument in the arts. Thus in the *Republic,* the arts are the apparatus for telling beautiful and medicinal lies. Children (and men with the mentalities of children) who could not be convinced by reason can be persuaded by images. Two

thousand years later Tolstoy was to insist that the great aim and opportunity, as well as obligation, of art was to communicate by contagion what it was essential for men to know, the common humanity of men and their common sonship in God. The arts by virtue of their geniality and their relatively universal intelligibility can be moral instruments where moral precepts and prescriptions would fail.

It has occurred to philosophers, though only lately, that it is not merely as languages to convey moral truths or moral essentials that the arts may be used, but that, in their practice and in their enjoyments, the arts are themselves instances or anagrams of moral philosophy; their images show what mind must prove. Moralities have demanded order, unity, and integrity. They have insisted that people be treated as ends, not as means. They have taught the sacrifice of the trivial to the important, the gratuitous to the essential. They have demanded discipline in the interest of harmony, centrality for the attainment of repose, and clarity as a way to peace. Is it not in point of fact precisely the elements of such a morality that distinguished practice in the arts illustrates and that trained enjoyment in the arts yields? The quality of a work of art, its savor, and its uniqueness,

are functions of an order of elements. That particular landscape by Cézanne, that quartet by Beethoven, constitute the uniqueness which they do constitute precisely because of, or rather in *being* precisely, those materials deployed in that exact way; were *anything* different in the picture, the picture as a whole would be different; vary the development of themes, lo, it is a different quartet. Did not the whole composition cohere, were its unity broken, it would be not *one* picture or *one* quartet. And did not the artist adhere with scrupulous fidelity to the order to which that work as it grew committed itself, there would be no order, there would be no unity, there would be a failure to achieve that irreplaceable quality we distinguish as the essence and internal signature of a creative work. An artist learns by repeated trial and error, by an almost moral instinct, to avoid the merely or the confusingly decorative, to eschew violence where it is a fraudulent substitute for power, to say what he has to say with the most direct and economical means, to be true to his objects, to his materials, to his technique, and hence, by a correlated miracle, to himself.

"To thine own self be true," Polonius cried. It sometimes takes an artist the good part of a long lifetime to learn what his artistic self is, and he learns it in the dis-

cipline of his art. No asceticism imposed from without compares with the *askesis* which an artist painfully develops in his work, nor can any dominating moral ideal transcend the centrality of temper and technique which a creator eventually may find for himself. Nor is there anywhere in moral theory or practice a better or more explicit lesson to be found than art provides in the importance of treating means seriously, of insisting that the means themselves should have something of the character of ends. In a work of art that has, in Cézanne's phrase, "realized," nothing is merely instrumental. Everything counts and is part of the organic life of the whole. Not only the artist himself, but the more discerning part of his public is quick to detect where other motives than the direct interest in the "realization" of the work itself have begun to operate. Fraud, professional tricks, elaborate or theatrical artifice, trumped-up emotions, these make the career of a temporary journalistic success in the arts, of the paid entertainer whose interest is holding the attention of a public always ready to be distracted by the next novelty. They have never made a work of deep or of permanent art.

In the arts, it is impossible to divide means from ends, to divorce motives from actions, or what is said from

the way in which it is said. This is not by way of pretending that an artist may not be a human being, too, with an eye to the main chance, or a hypocrite or a scoundrel in his human contacts. But in so far as he practices his art with *artistic* success, he practices it with objectivity, with detachment, or better, perhaps, with a passionate and scrupulous interestedness in his means, his materials, in their organization, in what he is saying and how he may most effectively say it. Nowhere, perhaps, save in the procedure of scientific speculation and research or of disinterested philosophical speculation (both akin to art), can the moral ideal of wholeness and harmony be better found.

There is again a moral ideal implicit, as was pointed out above, in the location of good in the present, the immediate, the actual. The arts are memorials of actuality and arranged festivals of the here and now. Ultimately, under any version of the good life, that good life is envisaged as being eventually lived. Even the longest view envisaging the most distant tomorrow must recognize that that tomorrow will sometime be a today. Even the hereafter is for those to whom it is promised a bliss experienced, when it comes, as a here and now. Heaven and the ideal commonwealth are images of what life might

*be* or what it is *going* to be. Within the pearly gates of the first, within the purlieus of the second are lodged the values, the cherished goods, the precious qualities not yet realized. Moral systems, when they are humanly serious, are engaged with nothing other than techniques for translating values into existence in the actual day-to-day experience of living, or statements of idealized versions of existence. A moral theory would be simply a vain speculation or a pernicious deception that was interested in removing evils or even in denying present goods without reference to some further promised good. Denial, sacrifice, discipline for the sake merely of denial, sacrifice, discipline are a form of masochism. The good may be called happiness or it may be called heavenly bliss. But bliss and happiness, when they are lived, are not promises or deferments; they are actualities and fulfillments.

The arts, therefore, not in theoretical formulas but in viable forms, exemplify the implicit goals, the realm of actualized or imagined value which any moral theory involves. The very goods of life which are the subject matter of ethics find their patent and palpable presence in the arts. There is scarcely any good which any moral theory might estimate or prescribe which is not thus illus-

trated and incarnated in some way in some art. Is it a sense of increased being and well being, a heightened and realized power such as is one of the criteria by which Spinoza estimates action? Where else more acutely than in artistic creation or than in the enjoyment of certain works of art does such a quickened and multiplied consciousness come than from certain works of music or of tragedy? Nietzsche observed this quality and character of art and referred to it as its Dionysiac side. No amount of formal analysis in the arts, no mere formal arrangement can account for the communicated strength, the contagious vitality of certain works in poetry or painting which we call powerful and feel to give us power. The artist feels it doubtless in creation; one of his most characteristic gifts is the insinuation of that sense of vitality into the listeners or observers of his work. If the function of moral theory is the ordering of life so that it may be most vital and realized, where else than in the arts at their most characteristic climaxes can that heightening and enhancing of experience be observed or found?

The life more abundant has been one of the classical clichés of ethical reflection. That abundance is attained in the generosities and sumptuousnesses of sound and color and words where the niggardliness and limitations of life

make it impossible or fail to provide it. And that richness of sensuous material in the arts, that intensity of feeling, are an intimation of what intelligent contrivance might make of all life, if the whole of life and of society should be made the materials of a comprehensive and major art. There is no reason in logic or morals why color and vitality, at present found in their purest and most intense form in the fine arts, should be confined to them, while the remainder of life is left routine, slavish, colorless and dull. The division between things of beauty and things of use is the function of a class heritage and a tradition of industry for profit only. But as the advances in industrial arts have shown, beauty may grace useful things, and, in a society where all were treated as ends rather than means, all would have an opportunity to share in work that had something of the self-rewarding vitality of artistic creation. Vitality is confined to the arts only in societies where the great preponderance of human activities is regimented and dead.

But moralists have traditionally been suspicious of the Dionysiac quality in art or in life. Vitality may mean barbarism in society, or hysteria in personal life, and both may lead to disaster. Men are not insects having their brief buzzing moment of ecstasy in an unrecurring

noonday sun. Life is an enterprise and demands a long view. To live well, to live at all well, demands a minimum harmony, and discipline is the only alternative to disorganization. The good life, in whatever terms the discipline be defined, demands control; there must be a gardening of the earth, or all the luxuriance will be nothing but weeds, only some of them by accident bright and briefly flowering. But here again the arts are moral teachers by example. For the same Nietzsche who pointed out the Dionysiac character emphasized also the Apollonian quality of art. The arts exhibit repose and peace no less than vitality and ardor. They exemplify them indeed rather more than life itself or the disorders of even apparently ordered societies possibly can.

There has been a deal of sentimental defense and sentimental attack on the Ivory Tower, on the desire, so often expressed in the late nineteenth century, and at the present day, for the arts as escapes. But if they are regarded as escapes, they are so regarded for intelligible reasons. They are escapes from the chaos of the internal psyche, the tormented or crucified spirit of the neurotic, or from the widespread social neuroses of a disorganized society, from complexes in the self and anarchy in the world. In the systematized spaces and volumes of a painting, in the clari-

fied procession of sounds in music, in the cadenced joy of poetry, we have order, we have harmony, we have peace. But here again the values assigned by moralists to harmony are unpretentiously fulfilled in the limited areas and selective perfections of the arts. Such harmonious arrangements are, however, not simply solaces and escapes. They are symptoms and premonitions. They intimate, they are anticipations of what order in society might be. The discipline, self-imposed and controlled by means and materials, is an indication of the vital discipline which avoids the chaos of barbarism or hysteria on the one hand, and on the other the factitious order of the regiment or the drill sergeant or the dictator. In the arts, individuality comes to measured realization. It is something that life has not yet found, either in democracies or tyrannies.

Thus it would appear that the positions of the artist and the moralist are in essence reversed. The moralist in the past has prescribed to the artist. We are, perhaps, only waking to the fact that the moralists may derive suggestions from the arts. For what they allege to be talking about, the values of life, harmony, happiness, vitality, a life luminous, rich, varied, perspicacious and intense, has been repeatedly and recurrently achieved by genius and enjoyed by the admirers of the masterpieces in the

arts. The latter are pictures of what life understanding it-self might be. In offering images of such realized goods, they urge gently by images that themselves persuade. They do not argue or command. They simply show. And what is shown is loved.

Values translated thus into immediately loved images have a powerful suasion on the imagination. They con-stitute, as many writers from Plato to Tolstoy have ob-served, a universal language, or at least a language far more widely communicative and compelling than the language of formulas, prescriptions, or commands. Re-ligions have preached the brotherhood of men; the social-minded have preached the co-operative adventure of man-kind. But the arts exemplify both. They speak with discipline out of the depths of feeling of things that hu-manly matter. They convert the urgencies of passion into the delights of feelings seen and heard at a middle distance. They speak, as major poems do, of profound themes but they make those themes into pictures, and those pictures into persuasions. They constitute the most genial and possibly the most effective moral legisla-tion of mankind. Tyrants have recognized the power of the song, the image, and the word. It is high time that serious and realistic moralists recognized them as well.

One more brief final point with respect to the moral aspect of philosophy and its relation to art. Moralists have stressed the ideals and the faiths by which and in the light of which men live. In art these ideals, as has been suggested in the foregoing, are uttered, are expressed, and are communicated directly as impressions. They are imprints on the imagination as vivid and as clear as the artist's gifts can make them. By virtue of their clarity and vividness they are persuasive as moralizing agents. They are the imagination giving a winning body to what reason might dialectically recommend. They are ideals whose certification is evident on their beautiful face. In the arts felt value and acknowledged validity are one.

The moral interest of philosophers in the fine arts has been almost a reluctant one. "Here," they seem to say, "is an activity in which men engage or which they persist in enjoying." They have attempted to eradicate or to justify their enjoyment or find a reasonable and fruitful place for the arts in the total human economy. But there are, perhaps, subtler explanations and more internal grounds for the philosopher's concern with the fine arts. For these singular and delicate diversions, so involved in

matter and in things, so suffused with feeling, seem by implication or by analogy to posit the same problems and to suggest analogous answers to those provided by philosophy, especially of the more mystical and transcendental variety. It was a poet who said Beauty was Truth, Truth Beauty, but philosophers have by more indirect and considered avenues sometimes come to the same conclusion.

There is no space to recount here the various definitions philosophers have given of truth. They have described it in terms of verifiable operations, in terms of correspondence with some absolute transcendent reality, they have declared it to be "a standard comprehensive description of a fact." But the "fact" by which truth is supposed to be verified, with which the truth is supposed to correspond, or of which it is said to be a description, is curiously recalcitrant to all formulations of it. The fact remains elusive of all descriptions. It is unique, immediate, absolute. It is a datum immediately given as is no description of it; it is individual as are no general terms about it. A fact in experience is, like Jehovah in the Old Testament, that that it is. No discourse is identical with the existence it analyzes or attempts to describe. The common noun, even the commonest nouns, are general terms.

The language of science and even of practical common sense is highly generalized and abstract. It is an instrument for reporting lowest common denominators, averages, normalities, recurrences, types. Meanwhile, experience in its directness and immediacy is a succession of uniquenesses, of individualities that are in a literal sense unutterable. Utterance is for the most part not designed to transmit the individual but to report the standard familiarity, the expected or calculable recurrences— for the most part. For there is a kind of utterance, the language of any art, which is specifically intended and, where it is successful at all, specifically successful in uttering the immediate tang, the direct quality, the unique savor of fact, an edged impact, a savored feeling, a moment seen through the artist's eyes and by a felicitous blend of technical craft and moral ingenuousness conveyed contagiously in a word, an image, a sound, a line, a facade, or a monument.

There seems to be something by no mere courtesy entitled to be called the truth that is the peculiar province of the arts. There is an external and, as it would sometimes seem, irrelevant truth *about* objects, situations, feelings, and events. There is a truth about things that is not the truth *of* them. The formula for water

is not its taste or its gleam. The astronomer's identification of the moon as a dead star two hundred and thirty thousand miles from the earth is not the truth of the poet speaking of the moon as the Queen of the Night. The physiology of love is not Tristan's and Isolde's sudden and terrifying absorption for each other that finds its speech in the swelling crescendo of the magic potion scene toward the close of the first act of Wagner's *Tristan*. There is poetic, dramatic, moral truth, truth that is the expression of a fact as humanly encountered or experienced, not a neutral description of its status in the total uncaring context of things. The arts give the truth of things as they have an impact in the feelings and imaginations of men. They try and sometimes manage to give not the bare generality but the vivid specificity of a fact, with all its hues of sense and feeling glowing upon it.

Philosophers have been suspicious of those utterances in the language of art which seem to say so much to which the heart and the senses assent but which cannot be verified by experiment as a formula can be verified, which cannot be demonstrated as logic demands. The truth of art, its moral and poetic truth, seems, compared with the truth of logic or of the laboratory, too vague and too ecstatic, too uncritical and too thin. Yet philosophers

and certainly all sensitive men and women have felt sometimes that the truth the arts utter is far more concrete and far more absolute than the formulas of logic and of the laboratory. They are utterances of the quality of experience itself, and that quality is at once more immediate and more absolute than the language of apparently sober and responsible practical prose discourse. The syntax of the arts, if it is not the syntax of nature, is at least a more adequate grammar for saying what men feel and see and hear than any of the generalized periphrasis of analytic diction. The truth *of* things rather than the truth *about* them finds its articulateness in the varied languages of the arts.

Furthermore, those languages themselves seem to come from something deeper and more compelling, to touch the being of things at a profounder level than the thin abstractions of philosophy and science. They are perhaps the only way of saying certain things at all, of uttering certain aspects of experience. The arts can scarcely be translated into each other or the style of one artist into the style of another artist; much less can they be paraphrased in the terms of science or practice. Like the utterances of certain mystics they are neither provable nor unprovable, they are neither verifiable nor dismissi-

ble; they open "another window for the soul" upon another world, upon what seems to the absorbed sharer of the experience, for the time being, the *real* world, a reality to which no other discourse initiates him.

A novel about characters whose originals we have always seen about us in our daily lives may speak the truth of them and make them real or reveal their reality—as one will—in a way no practical dealings with them and no sociological analysis of them ever could do. So, too, a painter may reveal a tree or a landscape to which we had made routine and unrevealing response. He may teach us by the impress of his own technically embodied vision to look at landscapes as he looked at them, and to look at them, so we feel, in their essential being for the first time. Or, if the poet's gaze be sufficiently wide and his technical gifts adequate, he may render the reality of God as no theologian or philosopher would be able to do. Above all, the uniqueness of a felt or perceived fact (as well as the fact of uniqueness) receives its celebration and its communication in the languages of the arts as in no other kinds of discourse. These others cannot imitate the arts, for neither science nor common sense is concerned with the realization of quality so much as with the technique of control. Art with its language of realization

may be a way the metaphysician has forgotten, not to describe but to *utter* reality. Perhaps such utterance is all that is possible and the "reality" of the universe is always experienced as some specific quality which it is the genius of art to render. It frees us from the abstractness to which common sense and demonstration and control habituate us. These have schooled us to neglect or to disguise the actual impact of the unique totality which is all that we ever immediately or directly know. Practice isolates the necessary aspect of some *that;* scientific discourse enables us to abstract "thats" into understandable and controllable operations. The arts do not tell us *about* or abstract *from;* they exhibit the *what,* the quality itself.

There is again another sense in which art is a revelation of truth. All our specific experiences, the perfume of the rose that is breathed, the presence of a friend or the cadence of his voice, have about them an unimaginable overtone, when we are receptive and alive. Something at our most intense or perhaps our most lucid moments makes the moment, the present, the actuality, glow with a being not exhaustively defined in terms of the physical sensation, an emotion not accounted for by the sensible character or the material form of the loved per-

son or the beautiful thing. There are occasions quite out-
side the arts, in love, for instance, and religion, that are
marked by this quality of poignant excess and divine in-
timation. It is the peculiar power of certain works of art
(not always the most ambitious or grandiloquent), to
touch off in us, to suggest in themselves, a real that tran-
scends the diurnal world of common sense and of com-
mon logic, the conventional geography of things in veri-
fiable relations and objects in routine connection. This
transcendent reality may be hinted at by a mere modula-
tion, as in some of the slow movements of Mozart's so-
natas; it may be brilliant yellow in a van Gogh, or a sud-
den line or two of Shakespeare:

> *"For God's sake let us sit upon the ground*
> *And tell sad stories of the death of kings."*

Beautiful things may genially beckon us to enter gladly,
tragic art may imperiously command us to enter, almost
with a kind of terror, into a realm to which practical and
scientific discourse have no sesame. At such moments the
power of art and the power of religion are very similar
and indeed may be said to be one. At such times the dis-
course of art ends in a dying close, a rapt silence; the
lover and the loved object are one. Nor is it without

significance that, on the one hand, much of religious ritual is a technique to induce such revelation, that in Greece ritual passed insensibly into drama and Greek drama remained religious in character and theme, that the Catholic Mass is drama, ritual, symbol, music, song, and picture in one. Plato, with all his uneasiness about the poets, knew what they possessed and communicated in such hierophantic vision, and that they spoke, often not quite knowing how themselves, of things deeper than save as poets they could know and that other men only in poetry could come to know also.

What, it may be asked, is this transcendent realm, and how shall one verify one's knowledge of it, and, unless it be verified, how can it be called knowledge? The answer must be similar to that of the pianist who having just played a Beethoven sonata was asked what it meant. He answered by proceeding to play it over again. What the arts reveal of deeper being can only be said by the arts, each in its own tongue. What it means to say that through the arts one comes in flashes to know this realm transcending common sense and common discourse, cannot be said in common sense and common discourse. It can be verified only in the sense that the experience of the arts repeatedly gives such awareness of such being to those who have

learned to have the ears for the special cadences and the special overtones of those discourses, varied and subtle, we call the several arts. To know in this sense is to know what would otherwise be unknowable and unutterable. The artists speak in terms of their art and they are understood. The otherwise unknowable becomes manifest, and a dimension is given to experience that cannot be denied when experienced, nor proven or disproven by that apparatus of experiment and demonstration which in their very terms exclude such a dimension. If in the experience of certain works of art we are made initiate to a character of experience that is the peculiar function of art itself, it is no use asking what common sense or common logic would make of it. It is very uncommon sense and a different order of logic because a different order of language we are concerned with. Reality, perhaps, can only be "realized," and it takes the language of art, or the occasional flashes of love or devotion to realize it.

Philosophers, reflecting upon knowledge and truth, must be given pause by the "something far more deeply interfused" that aesthetic, like religious, experience reveals. They have of late wakened also to the fact that the activity of art itself, its creation and enjoyment (the latter, in part at least, a vicarious creation), throws light on

the whole of experience and is perhaps its most complete and characteristic flowering. Latterly thinkers as different as John Dewey and Havelock Ellis have come to conceive of experience itself as an art, and art as simply a generalized name for intelligence. To conceive of life as an experimental process, occurring through the vicissitudes of time, is tantamount to regarding intelligence as a directive and disciplined imagination which makes that strange interlude as stable, as various, as delightful, and as harmonious as the ultimate and fateful limits of nature will permit. It is equivalent, too, to regarding the practice of intelligence in the world as being simply a larger case of effective practice in the arts. There, too, the conditions must be understood, chances must be taken, audacious flights embarked upon, and there must be a steadying of the dream by understanding. Man is the fortuitous child of a changing and precarious environment. Ideas, themes, intuitions occur to the artist as they occur to the man in the street or to the man in the laboratory. But these ideas in existence or in art must be realized by understanding, by discipline, and by control. Nature generates the materials and the ideas by the happy union of which ideals may be realized. In art, the field being relatively simpler, intelligence is more spectacu-

larly successful. But every success of intelligence in life is an example of human art; every success in the fine arts is a delicate and dazzling instance of what constitutes the success of intelligence anywhere, that is to say, of rational art, the turning of the fitful opportunities of materials to ideal uses of stable and ordered delight. This last point is curiously but patently confirmed by the way in which criticism arises in society, morals, and art. Intelligence develops standards of criticism, a reflective examination of the effectiveness of its own procedures in the control of nature and human nature. In the practice of the arts criticism arises, too, in the discrimination of effectiveness in the use of means, in the ordering of materials, in the transparency of realization.

Criticism in connoisseurship is simply the application of standards to perception, like those the artist, the scientist, and the practical man use for estimating the effectiveness of their techniques. Criticism does for our discrimination what it does for our control. It is simply perception become exact and enlightened. It is not legislation, it is not vague appreciation. It is, through a training in exactness of perception, in historical sympathy, in intellectual understanding, the education of taste to purity, clarity, and intensity. Criticism is, in the arts as in life, simply ex-

perience become conscious, careful, precise, and disciplined. It is the imagination both nourished and nurtured. Ultimately what criticism tries to elicit in the fine arts, the discrimination of values intrinsically justified, is a clue to the business of all philosophy, the criticism of criticism, the ultimate attempt to define and discriminate value.

There are, finally, two senses in which the business of philosophy and that of art in their major conceptions flow into each other. All art is, in the first place, a creation and a construction. So, too, for all its other claims, is philosophy. The painter contrives a little world on canvas; his materials are color and line, his theme is a single act of visual apprehension. That room, those people, these fruits or flowers, are made organic, suffused into a single world of perspective and of light, and given the integrity of a perspicuous composition, the luminous interpretation of a mood, of line and light. The poet fuses a hundred images and cadences and echoes of remembered things into the single congruous mood of a poem. The musician, out of all possible combinations of sound in the infinite resources of tones, makes an organized realm of notes into a sonata or a symphony.

The philosopher, like the artist, is at once selective and constructive. Out of all the manifold data of human

experience, he selects certain salient and crucial facts, and, out of all the principles by which facts may be classified, he selects certain principles, and, by virtue of these, contrives a system of metaphysics, an ultimate code of morals, a fundamental vision of nature, life, and destiny. The artist, we say and think (as he himself says and thinks), selects his facts and materials and gives them their particular order by impulse, reflectively disciplined. So, after all, does the philosopher. Seen in the long perspective of the history of thought, a world view, a metaphysics, a way of life, like a poem or a painting, is an aesthetic response and, where it attains organic unity in principle or in mood, provokes an aesthetic response. Seen without fanaticism or prejudice, it comes to be appreciated, too, like a poem, or a statue, or a cathedral. As abstract as the structure of music, it may truly enough lack the immediate sensuous charm of art, and the emotional drives incarnate in it may be so ascetically subdued and transmuted that it seems—instead of being the concentrate of passion it frequently is, "thought become passionate, the passions become cold," as in the *amor dei intellectualis* of Spinoza—to be passionless and dead. But to those who have learned to follow it in its own terms and with imaginative sympathy, it is as compelling emo-

tionally as a poem or the façade of Chartres, and, as in the case of St. Thomas' *Summa,* is as much an imaginative product of its period. It is revealing of the feeling of the age and the thinker no less than of his thought.

The form of a philosophy may be less obvious or more difficult and is embodied in less immediately glamorous materials. A philosophy seems at first glance or in the midst of one's study of it to have much more to do with the disinterested plodding inquiry into truth than in the interested passion for beauty. But a philosophy, too, has its wonders of form and structure; the architecture rather than the truth of Kant's *Critique of Pure Reason* is its fascination for many readers. But the form of a philosophical system, like the form of a work of art, is a way of saying something, and something passionately and comprehensively important. For those to whom philosophy is more than a technical abracadabra or jargon, or a making of distinctions for the sake of virtuosity in making them, a philosophy has the imaginative and emancipating power of any other work of art. Like a painting or a poem it is another and realizing or enkindling way of looking at the world. This being the case, it is not surprising that philosophies differ. It is always the same world, but philosophers look at it differently,

and it looks different, given their varied systems of discourse, as the world looks different in a Breughel or a Cézanne, in a Watteau or a Degas, or as it sings differently in Beethoven and Mozart and Debussy. Ultimately, when the argument has simmered down in a philosophy, it, or what it simmers down to, is an integral act of insight, an intuition. When all is said and done about a philosophy, even by its author himself, a philosophy remains a way of looking at things and in terms of that regard of estimating them.

Philosophers as different as the absolutist Bradley and the empiricist Dewey admit or insist that all philosophy is discourse about what (call it experience or call it the Absolute) is inscrutable or indescribable. Experience remains at its core a mystery, which at any moment may become clarified in one aspect of it; it is an immediate act of apprehension or of vision. In philosophy the aspect seized upon is wide and sweeping, as it is, too, in major poetry. The mystics call the unutterable core of being the One. But the One has taken a thousand different forms. The artist is the true revealer of the mystery; the aesthetic observer, when he is truly alive in vision and appreciation, is the true mystic. For in a work of art he has recognized one aspect of the One, clear and passionate and

intense. Experience has become for him for that moment a lucid flame; the universe with which he identifies himself is, as the universe in itself may not be, a living order, a single ordered life. He is, in the experience of beauty, to use the now well-worn language of Plotinus, for a moment at one with the One, at home in the Absolute. And be it in the language of philosophy or of art, a man mortally present has caught and communicated a glimpse of the eternal.

# Norton Paperbacks in Philosophy

### SIGMUND FREUD IN THE NEW
### JAMES STRACHEY STANDARD EDITION

# *In the Norton Library*

## CRITICISM AND THE HISTORY OF IDEAS